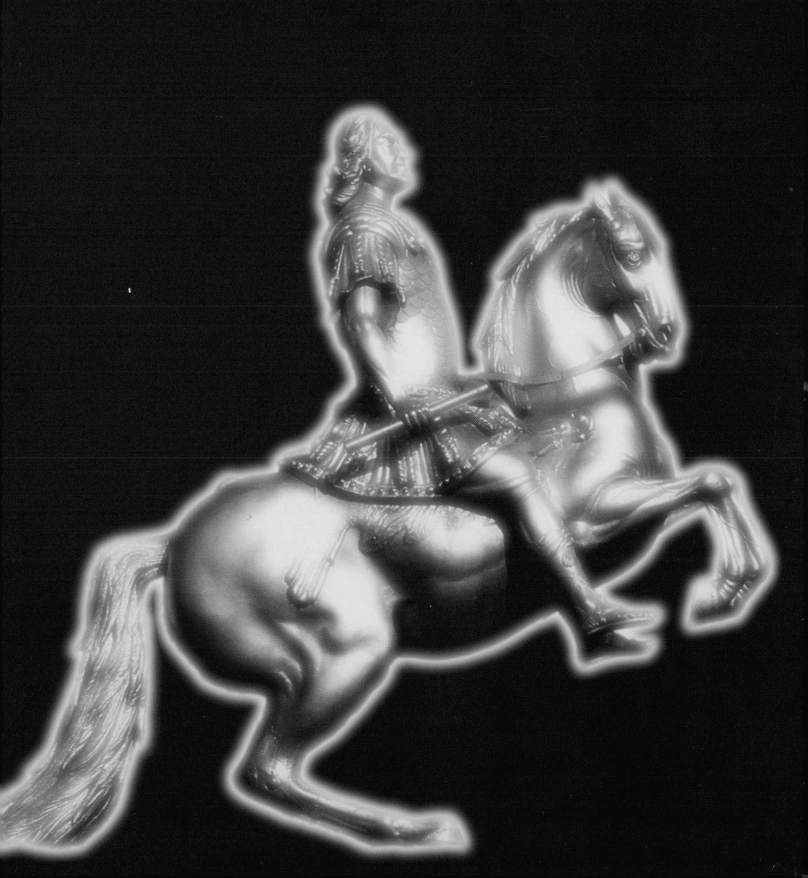

Journey through

SAXONY

Photos by

Tina and Horst Herzig

Text by

Sylvia Gehlert

Stürtz

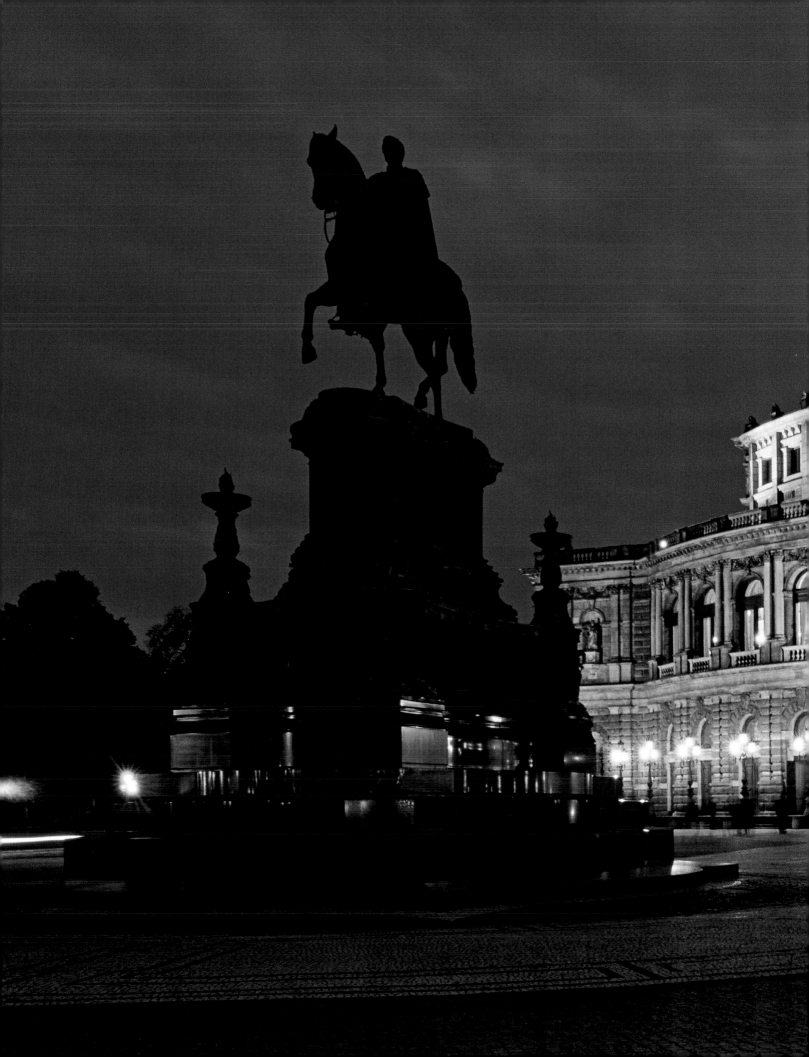

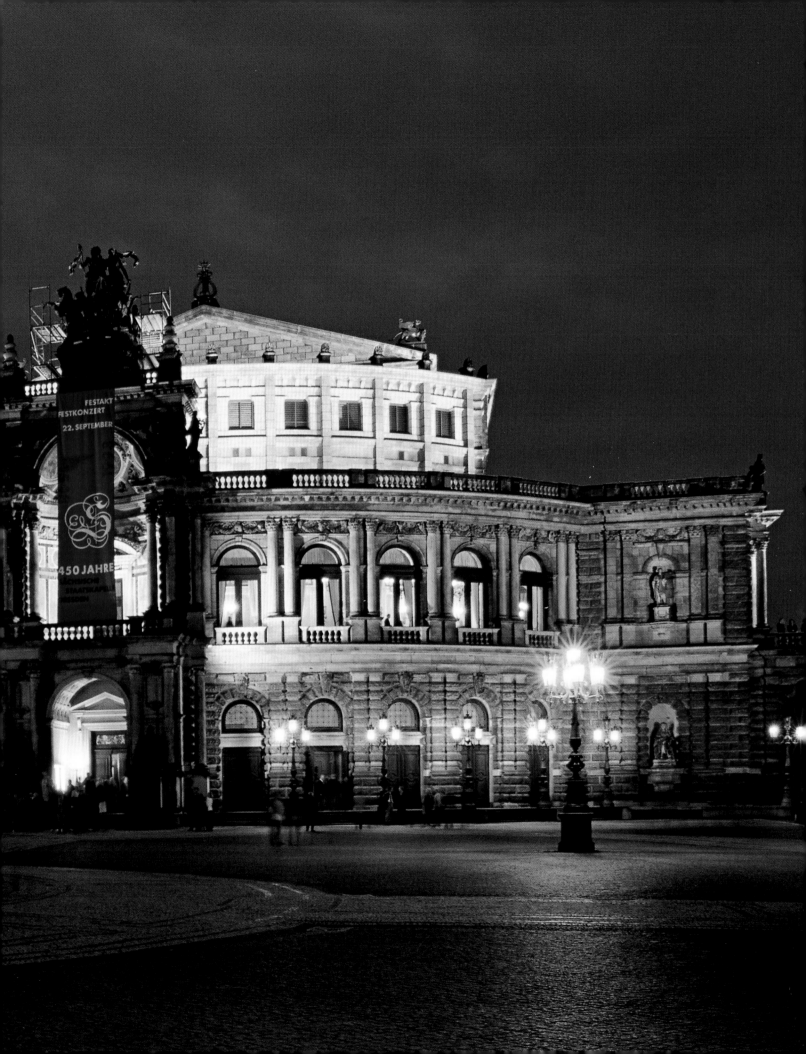

CONTENTS

First page:
Saxony boasts a verita-
ble wooden wonderland
of children's toys and

Christmas decorations.
Angels of light, candle
arches, Christmas pyra-
mids, nutcrackers and

pipe smokers made in the
Erzgebirge have brought
pleasure to generations
of kids and adults alike.

revious page:
n February 13, 1985,
rty years after its
estruction, an exact

replica of the Semper-
oper in Dresden (Semper
Opera House, depicted
here) was reopened.

Below:
Richter's coffee house.
In 1720 there were over
30 coffee houses in

Leipzig's Katharinen-
straße alone; the new-
fangled beverage had
taken the city by storm.

Page 10/11:
The seven arches of the
Bastei promontory have
spanned the precipitous
gorges of the Elbsand-
steingebirge since 1851,
providing generations of
intrepid visitors with

spectacular panoramas.
In the same year the first
trains began chugging
through the valley of the
Elbe to neighbouring
Bohemia; paddle steamers
had been navigating the
river for almost a decade.

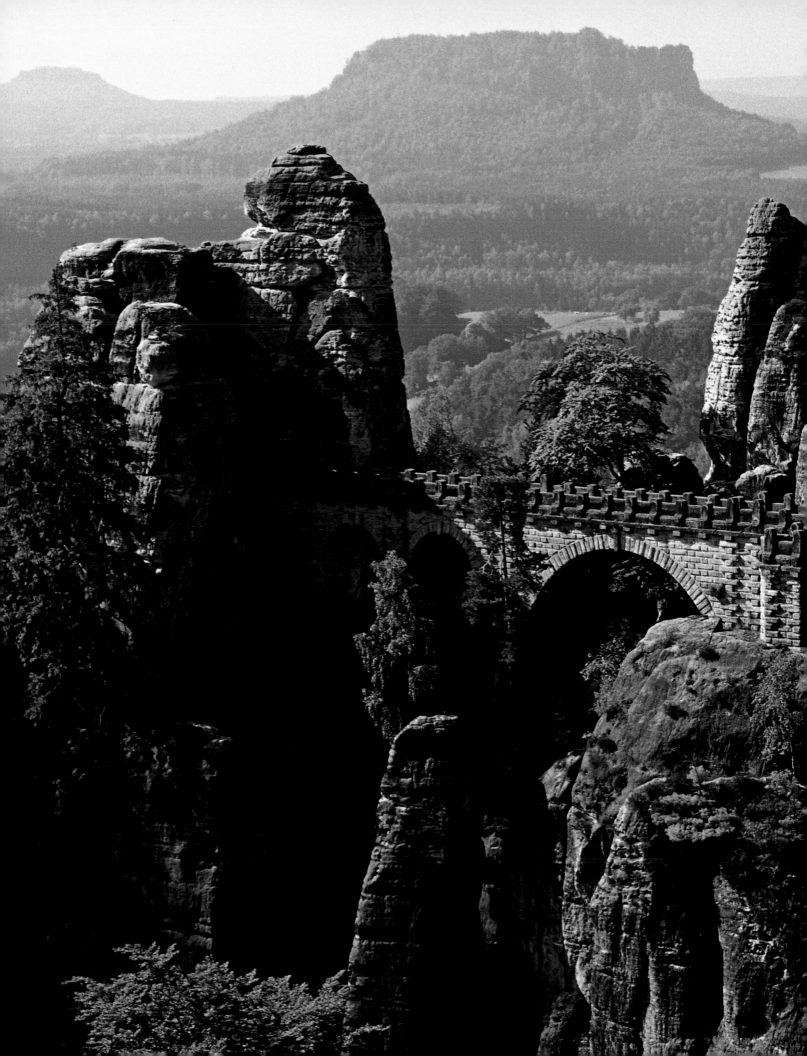

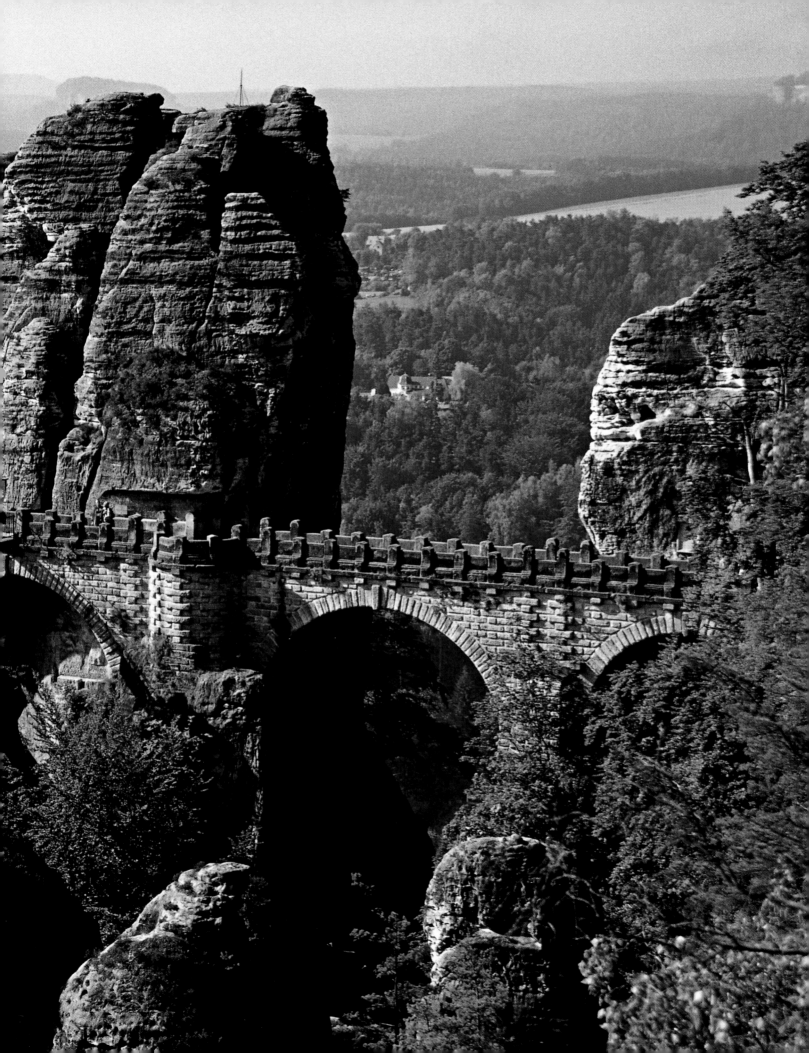

Sculptor Carl Seffner fashioned this determined likeness of a purposeful young man to commemorate Goethe's years as a student in Leipzig. The two girls on his medallion show where the scholar's thoughts lie; not with his books but with his flame Käthchen Schönkopf, the daughter of a local publican, and his confidante Friederike, whose artist father Adam Oeser gave the young Goethe lessons.

The story of Saxony – and that of the indigenous population – is not the easiest tale to tell, but no less exciting for it. Let's start from the very beginning, namely with the land itself. The present terrain – a free state, no less – is now not even half the size of the grand electorate it once was – and the Saxons themselves aren't really Saxons at all, but a mixed bag of creeds and colours thrown together by the ravages of time. Maybe that's what makes life here so stimulating, with the local ethnic makeup marrying vigour and drive with natural wit, warmth and friendliness, a modicum of composure and a light-hearted ability to poke gentle fun at themselves and their fellow human beings. Grumpy, quick-tempered, narrow-minded Saxons, know-alls and party-poopers totally devoid of a sense of humour are few and far between and if one of them does happen to cross your path, then he or she is the famous exception to the rule – in Saxony as anywhere else in the world. The Saxons themselves, with tongues firmly in cheeks, also have a few words to say on the matter, namely in one of their favourite rhymes which goes something like this:

Us Saxons, we're not stupid: the world knows that's a fact,
And if we sometimes play the fool, we're putting on an act!

The first inhabitants of the region date back to the Stone Age, as excavations near Leipzig have shown. The area wasn't permanently occupied until the 4th millennium BC, with early settlers building dwellings in the river valleys with their fertile loess soil and later in the foothills of the Erzgebirge

THE HEART OF EUROPE

and Vogtland. During the first centuries AD Germanic Hermunduri are recorded along the Middle Elbe; they later wandered west during the migration of the peoples. We can only make assumptions as to why; one theory suggests that a prolonged period of cold induced them to go in search of milder climes. The region was suddenly almost devoid of human habitation, its beautiful countryside perhaps made the more enticing by the lack of inhabitants. During the 6th century Slavonic tribes from the area between the Dnepr and Oder rivers in Bohemia were drawn to this quiet haven, peacefully settling in hamlets which they gave Slavonic or Sorb names. In the wake of Germany's colonisation of the east at the turn of the millennium these tiny villages mushroomed into towns such as Leipzig, Dresden, Meißen, Bautzen, Chemnitz and Zwickau, to name but a few. Most of the older place names in Saxony have Sorb origins; those that start with the word "Windisch" (Wendish), such as Windischleuba in mining country south of Borna, are a reference to the Germans' term for the Sorbs, the Wends, which the Sorbs themselves detested. Nevertheless, the ancient denominations have stuck.

And now we come to the word "Saxon" itself. Like the Sorbs or Wends, the Saxons obtained their title from somebody else, somebody far removed from their part of the world. Once upon a time in Holstein in Northern Germany there was a Germanic tribe whose warriors liked to hack away at their opponents with a one-edged sword called a "sahs" or "sax", prompting a Roman historian to refer to them as "saxones". During the 5th century a number of these hooligans of yore teamed up with their equally brutal neighbours, the Angles, and set sail for Britain, seizing supremacy and adding their gene pool to the ethnic (and now Anglo-Saxon) collective in the land of the Angles. Those remaining on the Continent were decimated by the Frankish armies of Emperor Charlemagne during the Saxon Wars; those who survived converted to Christianity. The Old Saxons soldiered on west of the Harz Mountains under the rule of a duke who in 919 was crowned Henry I, king of Germany, by both Franks and Saxons in Fritzlar. The Saxon promptly decided to invade the Slavonic territories along the Elbe and Saale rivers, bequeathing his tribal designation to the land and people he sought to conquer.

With a brief regal flourish successor to the throne Otto I furthered Henry's cause. He dispatched a team of margraves to "pacify"

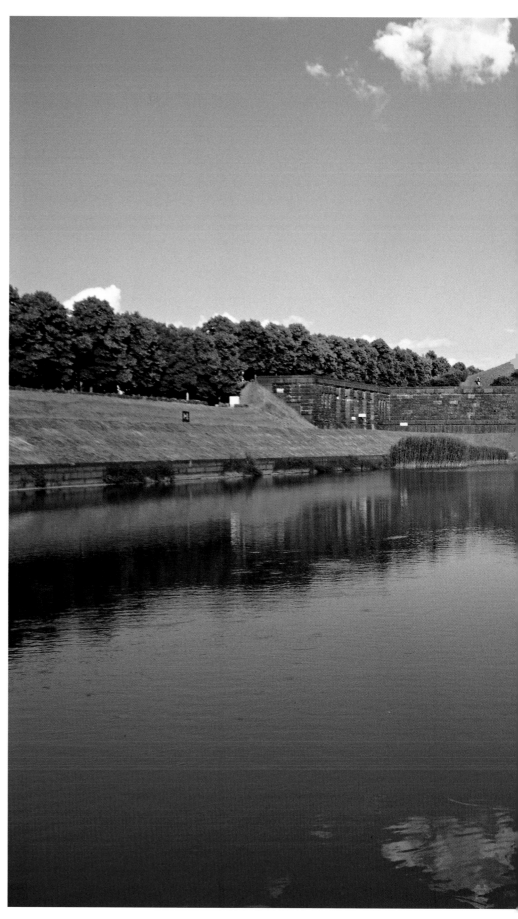

the eastern reaches of the empire post-haste – and then more or less washed his hands of the whole affair, leaving his vassals to their own devices while he concentrated on other royal business. A bishopric was founded hot on the heels of margravate Meißen to placate the wild and wily heathen slaves with the words of the Good Book. The newly converted became Saxons like all those who followed them to the outlying territories to make a living for themselves. Over the centuries many flocked to the region: craftsmen from the Frankish Kingdom and Flanders, mountain folk from the Harz, Protestant refugees, Huguenots from France and many others fleeing persecution and oppression. They brought with them their knowledge and skill, their customs and cuisine. Saxony offered them a safe haven, greatly profiting from its new populace of craftsmen and traders, miners and farmers, artists and scholars. The state boomed, with one of its two duchies being made an electorate in 1423, propelling its sovereign to the pinnacle of power and giving him the right to help elect the Holy Roman emperor (hence the term "electorate"). To differentiate between the two territories the western home of the original Saxons was henceforth called Lower Saxony, with the electorate to the east becoming known as Upper Saxony or, later, just Saxony.

THE CRY OF THE MOUNTAINS OR HOW THE ERZGEBIRGE GOT ITS NAME

We now go back to the year 1168 and to the precious find which was to catapult Saxony to wealth and prosperity. Salt traders were travelling from Halle to Bohemia, their wagons making deep groves in the muddy tracks which wound their way through the mountains of the Erzgebirge. Suddenly they noticed something glittering in the mire beneath their wheels: silver! The mountains were full of silver ore! Their exultant cries echoed far and wide, bringing miners scurrying to Saxony and the promise of fortune. Mine shafts were dug and Germany's first free

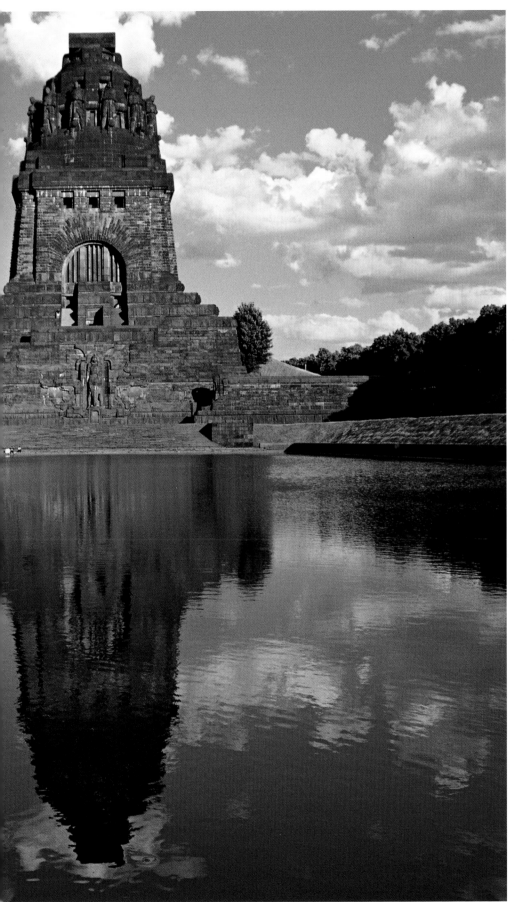

mining town, Freiberg, established. Despite the obligatory tithes and taxes collected by local rulers the town blossomed during the silver boom, becoming the most heavily populated and most significant centre of trade and finance in the Erzgebirge within the space of a few decades. It adorned itself with magnificent buildings and works of art and erected a mighty town wall defended by no less than 39 formidable towers. Towards the end of the 15th century the cry of the mountains once again filled the air, this time in Schneeberg and Annaberg. Here, too, silver was in abundance; if people didn't live off the mining, they could certainly live off the industries which served it. There was timber to be cut for the pits; mining families needed food, clothing and a roof over their heads. Retail trade, crafts and many new professions such as clothmaking positively boomed. Braid trimming was another, providing women and girls with an essential source of income when in c.1560 the silver deposits which could be mined with the crude machinery of the day were finally exhausted. The remaining residues in the iron ore, hard coal and cobalt mines provided only a handful of pitmen with work. The Erzgebirge, or "ore mountains", had temporarily failed them.

But their knowledge and experience lived on. Georg Bauer or Georgius Agricola from Glauchau, a natural scientist, doctor and the mayor of Chemnitz, laid the foundations for the coal and steel industry in his twelve-volume work "De re metallica", published in Basle, Switzerland, in 1555 shortly after his death and soon circulated all over Europe, translated into a number of languages. His contemporary Adam Ries(e) moved from Upper Franconia to Annaberg (the second-largest city in Saxony with 12,000 inhabitants) where in 1539 he was made royal arithmetician to the electorate of Saxony – in other words, minister of finance to the mining industry. His popular books of arithmetic went like hot cakes, second only to sales of the Bible. The present community of Annaberg-Buchholz still commemorates the great man in a competition where budding mathematicians from Saxony, Thuringia, Bavaria and the Czech Republic are invited to solve extremely complicated numerical problems. The next generation of miners was catered for in 1765 when an academy of mining was opened in Freiberg, one of the oldest of its kind. True to the style of Leibniz – of teaching theory and practice side by side – the present university is the only one to have its own college mine.

A CITY IN THE MAKING:
FROM MARKET
TO TRADE FAIR

In Leipzig, not far from the Grimmaische Tor, two important medieval trade routes once intersected. The Via Regia ran from Madrid through France and via Aachen to Novgorod and the Chinese silk route, with the Via Imperii linking Scandinavia to the Mediterranean and the Levant. In a letter of safe conduct from March 1, 1268, local lord Margrave Dietrich granted all merchants who wished to trade in Leipzig or owned warehouses there his full protection. With thieves and bandits haunting the roads and highways, his offer was gratefully accepted. Leipzig was also given the right to hold three "annual markets" a year – in spring, autumn and over the new year – and the privilege of being the only town within a 50km radius which could store and handle exhibition goods. The range of items was enormous. Just about anything which could be safely transported and quicken the hearts (and purses) of prospective buyers from all over the world found its way to Leipzig: textiles, fur, spices, food, weapons, wines from abroad, household gadgets and luxury goods, fashion articles, glass, porcelain and ceramics, toys and musical instruments – and even livestock, with avid fairgoer Augustus the Strong regularly undertaking the journey to Leipzig to purchase mounts for his Dresden stables.

Leipzig grew with its trade fairs to accommodate their every need. One characteristic trait of the city are the many merchant stores with their wide courtyard passageways, some of which have been saved and restored as elegant shopping arcades. Coaches were able to drive in one side of the store to inspect the wares on sale and then drive out again, without having to turn round, on the other side. When a fair was on in Leipzig the city was abuzz, with a different language being spoken on every street corner and no room at the inn for love or money. Even the students – Goethe among them – were booted out of their digs for the duration to cater for wealthier tenants.

The industrial revolution then hit Saxony, already in the throes of technological advance. With it came the railways, with the first long-distance connection in Germany running from Leipzig to Dresden. Both instigated change. Mass production facilities meant that identical copies of goods could be manufactured in any quantity required.

These could now be sent directly to customers by rail without having to be sold through trade fairs. A sample was sufficient for sales purposes. Leipzig's councillors didn't waste any time. At the end of the 19th century they decided to build a palatial exhibition hall for the samples fair or "Muster-Messe", with two intertwined Ms as its readily accepted logo. The furriers alone remained where they were (for centuries Leipzig had been the hub of the fur trade). Their materials and products were all unique specimens, each of which had to be perused in daylight which flooded into the air wells of the stores and workshops with their enormous windows.

HOME OF THE BOOK AND THE PRESS

The first daily newspaper in the world was published in Leipzig in 1660. In the world of books Leipzig soon outstripped book trade metropolis Frankfurt. The sale of books at the Leipzig fairs in turn promoted the setting up of publishing houses and printing workshops in the city itself, cutting down on costs for transportation. The elector also exempted the Leipzig book trade from duties; his censorship, too, was less stringent than that of the emperor. 234 booksellers from all over Europe converged at the book fair in Leipzig in 1802. Brockhaus took his encyclopaedia to the city; Reclam launched its now famous Universal-Bibliothek edition here with Goethe's "Faust". In 1853 "Die Gartenlaube" (The Garden Arbour) began publication, the first popular Sunday paper containing reading material for the whole family, with over 400,000 copies of each issue printed. By 1880 Leipzig had 350 stores selling books, art prints and sheet music, plus 82 printing houses, 72 lithographic workshops and 200 bookbinderies, most of which were housed in the "graphic quarter". When the area was bombed at the end of 1943 1,000 businesses were annihilated or heavily damaged and 50 million books went up in smoke. They sadly weren't the first; like everywhere else in Germany, Leipzig staged its first burning of books on May 10, 1933 – without any help from foreign quarters.

WHITE GOLD AND BLACK CHIMNEYS

In 1701 rumours at the Prussian court had it that a certain Johann Friedrich Böttger, an excellent experimenter at a Berlin chemist's and a would-be alchemist, was able to make gold. Before King Frederick I could get his hands on him the young man fled to Wittenberg – out of the frying pan and into the fire. His reputation had gone before him. Augustus the Strong, the elector of Saxony who had recently been crowned king of Poland, costing him a small fortune in bribes, seized Böttger and flung him into prison at the Königstein fortress under orders to start making gold in his royal laboratory – pronto. Mathematician Count Ehrenfried Walther von Tschirnhaus joined forces with Böttger and the two men worked together on a formula, reaping success in 1709 when Böttger produced the first "white gold" (porcelain) in Europe out of kaolin from the Erzgebirge. If fired several times over, this proved much harder and more resilient than bone china which at the time was a highly desirable item at courts throughout the land. In 1710 the Königlich-Sächsische Porzellanmanufaktur (Royal Saxon Porcelain Manufacturer's) was founded in Meißen under the auspices of Böttger whom Augustus the Strong only released from captivity four years later. Sadly he didn't live long enough to see his "invention" flourish, with the installation of Johann Joachim Kändler as master sculptor in 1733 cementing the factory's success. For 45 years Kändler created imaginative and beautiful artefacts for the upmarket dining table. He also produced a microcosm of dainty Rococo figurines which, while swords were crossed and canons were fired in the rough and bloody world outside, encapsulated the other, playfully sensuous and optimistic side of the late 18th century.

While Dresden was busy turning its white gold into hard cash, the old textiles metropolis of Chemnitz had became the number one industrial venue in Saxony, with its trading capacities second only to Leipzig. Saxony was now a kingdom at the grace of Napoleon; the glory was short-lived, however, for ten years later it found itself on the wrong side at the terrible Battle of the Nations and was subsequently forced by the victorious powers at the 1815 Congress of Vienna to hand over much of its land to Prussia, promptly demoting it to Prussian province.

The Saxons refused to be beaten. Many headed for Berlin and the promise of work. To earn an extra crust Saxon housewives be-

Open country near Obercrostwitz in Upper Lusatia in the heart of Sorb land. During the 7th century Slavonic tribes – the Sorbs among them – began populating the deserted terrain of eastern Germany from the Erzgebirge to the Baltic, from the River Saale to the Oder. They lost their independence 300 years later when they were conquered by the Germans; their territories were assimilated by the German empire and the "heathens" subdued and converted to Christianity.

gan serving fresh cake and coffee in their front gardens to Berliners out for their Sunday stroll. The publicans of the city were outraged and protested loudly, achieving a ban on the sale of coffee. Ingenious to the last, the Saxons retaliated by giving the ground coffee away and only charging for the hot water, enticing families to come in and make their own.

Back in Chemnitz the scene was less idyllic. In 1859 it was so filthy that one contemporary called it "the Manchester of Saxony" where factories and foundries belched permanent clouds of black smoke into the atmosphere. Its locomotive and machine industries may have been internationally famed – but so was the abject poverty of its proletariat. In 1863 Ferdinand Lassalle set up the Allgemeiner Deutscher Arbeiterverein (General German Workers' Association) in Leipzig, the first party for the working class. In the same city in 1865 Louise Otto-Peters from Meißen became president of the Allgemeiner Deutscher Frauenverein (General German Women's Association) which fought for the right of women to education and gainful employment.

These were small steps towards a better future for the common man – and nails in the coffin of the powers that be. From Martin Luther to the Peasant Wars, from the revolts of 1830 and 1849 to the proclaiming of the Saxon republic in 1918 – in a circus tent, the only place big enough to harbour the crowds – the Saxons have persistently chipped away at the rocky foundations of dictatorship. Finally, with the Monday demonstrations in the Nikolaikirche and the public demos in Leipzig and Dresden in the late 1980s, Saxony caused the structure to finally crumble, making its invaluable contribution to the inevitable collapse of the Berlin Wall.

LOOKING BACK TO THE FUTURE

Entrepreneurial expertise and historic trials and tribulations aside, we shouldn't forget the inventors, scholars, artists, musicians, poets, adventurers and engineers to come out of Saxony. Melitta Bentz, for example,

In 929 the German king Henry I had a fortified military camp erected on top of the castle mound in Meißen. This later became an imperial fortress, with the first bishop taking up residence in 968. The margraves of Wettin gradually secured and extended their territories which were to form the basis of the electorate of Upper Saxony. The present Free State of Saxony was re-established in the hall of Meißen's Albrechtsburg on October 3, 1990.

was one of the state's bright sparks, a Dresden housewife who in 1908, fed up with drinking the dregs with her coffee, took a hammer and nail and banged some holes into the bottom of a brass saucepan, then lining it with tracing paper from her son's school exercise book. The result was the first Melitta coffee filter, now a standard requisite in any German kitchen. In 1910 engineer August Horch set up an automobile company in Zwickau called Audi (Latin for "horch" or "hear"). On joining forces with fellow manufacturers in the 1930s the Saxon Auto Union was born whose progressive models and successful racers catapulted the concern to international fame. Despite heavy damage during the Second World War the plant was salvaged and on July 10 1958 mass production of the P50 began, just one year after the successful launch of the Soviet Sputnik ("companion"). In honour of its Russian counterpart Zwickau's Duroplast two-stroke was named the Trabant ("satellite" or "follower"). The first German to enter outer space aboard a Soyuz spacecraft in 1978 was cosmonaut Sigmund Jähn from Morgenröthe-Rautenkranz. Plauen in the Vogtland began industrially producing lace for window panes, sideboards and ladies' underwear in 1866. At the beginning of the 20th century in the garden city of Hellerau the Dresdner Werkstätte pre-empted the Bauhaus with their functional furniture, where simple, non-elaborate forms of expression triumphed. In the same period four art students from the Technische Hochschule (technical university) in Dresden founded Die Brücke (The Bridge). They painted the meadows of the River Elbe in glaringly bright colours and their female companions as Eves in a worldly paradise on earth, horribly offending the prevailing academic tastes of the time. What, cried their critics, did this have in common with the transfigured romanticism of Caspar David Friedrich, who had adopted Dresden as his creative domain, or with the fairy-tale Biedermeier of Grimm illustrator Ludwig Richter?!

Saxony has always refused to go with the tide. It made music German, for example, when at the beginning of the 16th century it

was the Italians who set the tone. One of their pupils, Heinrich Schütz, used what he had learnt in Italy to create his own distinctively German melodies and harmonies. The Saxon choral institutions of the Leipzig Thomanerchor (Choir of St Thomas's) and Dresden Kreuzchor, both founded in the Middle Ages, are still very much alive. Mendelssohn resurrected the works of Bach in Leipzig; another Leipziger, Richard Wagner, began his search for the ultimate synthesis of the arts here; Carl Maria von Weber from the chilly north was inspired by the ragged peaks of the Elbsandsteingebirge to write his "Freischütz". Saxony was also the home of Karl May and Hedwig Courths-Mahler, often scorned for their trivial literature but nevertheless successful in touching the hearts of millions of readers with their demonstration of the good in people, firing the desire to read.

Saxony hasn't waited for the official ceremonies marking the expansion of the EU to become a binding force in the centre of Europe. In the pocket of land between Germany, Poland and the Czech Republic – and by no means just here – for years the emphasis has been on cross-border collaboration and a return to a common cultural denominator with a view to the future. Welcome to Saxony, where the heart of Europe beats stronger than ever before.

Page 22/23:
The 1,000-year-old city of Bautzen – or Budysin in Sorbian – clings to a granite elevation high up above the River Spree. Its compact old town is delightful, with street signs in both German and Sorbian indicating that Sorb culture is still very much alive here. The local museum is also dedicated to regional traditions and customs.

Page 24/25:
The academixer cabaret act was formed in 1966 by students at Leipzig University. Now a professional setup, the comedians still regularly offer their witty interpretations of current affairs and politics, with plenty of music and smatterings of local lingo to enliven their performance. They still play at their original venue on Kupfergasse, with the Mixer bar on hand for liquid sustenance before and after the show.

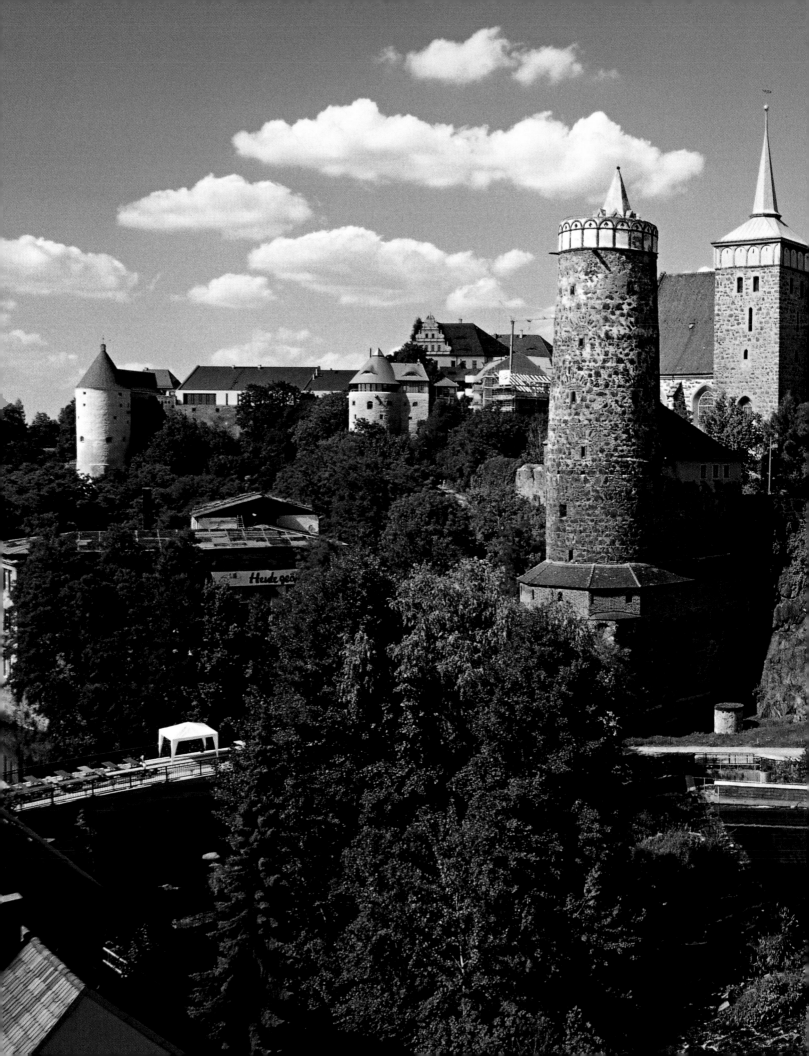

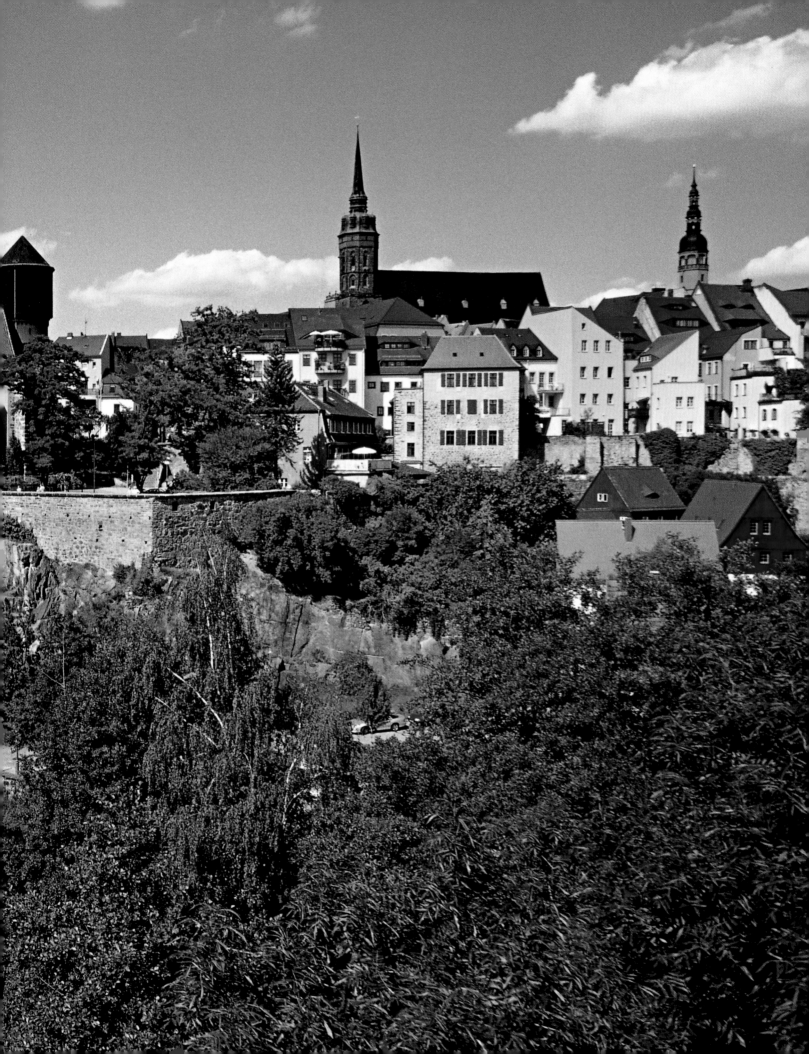

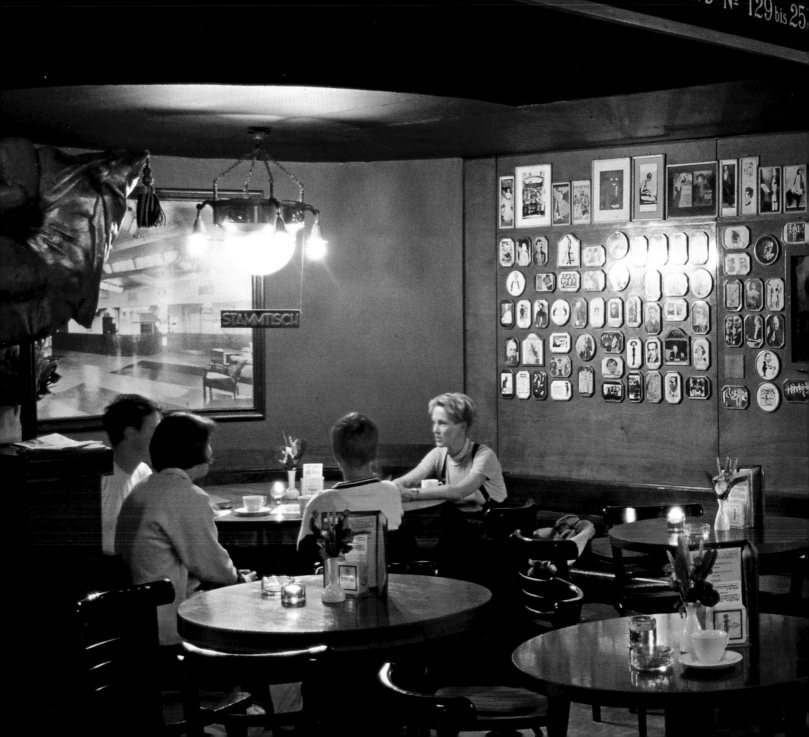

D R E S D E N

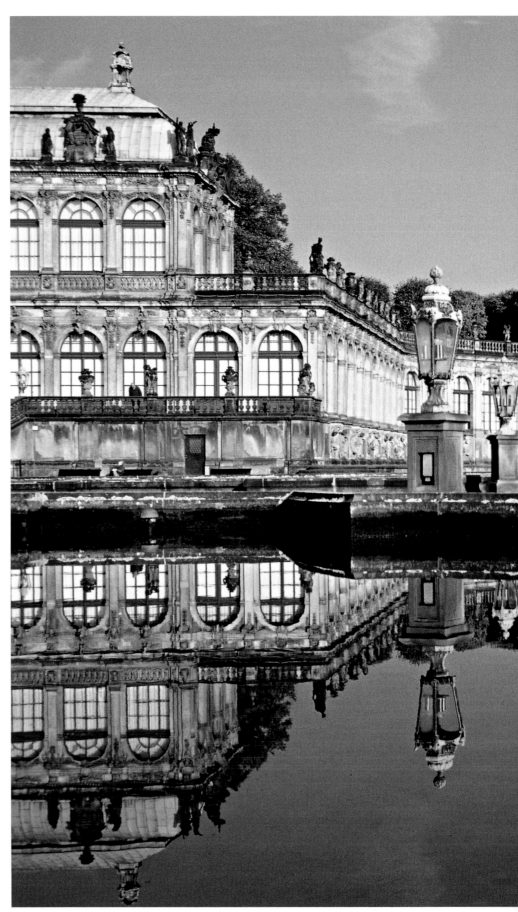

Dresden's Zwinger is a masterpiece of the baroque, marking the pinnacle of Augustus the Strong's artistic career. Architect Matthäus Daniel Pöppelmann and sculptor Balthasar

Permoser to the elector of Saxony and king of Poland were the men who realised the monarch's visions of Italian and French splendour and elegance.

"The past and the present lived together in unison. Or should I say harmony. And with the countryside, with the Elbe, the bridges, the sloping hillsides, the forest and the mountains on the horizon, one could almost call it a symphony. History, art and nature lingered over the city and the valley, from the cathedral in Meißen to the park at Großsedlitz, like a chord of notes enraptured by its own sound." Thus wrote Erich Kästner in his book of childhood memoirs, entitled "Als ich ein kleiner Junge" war (When I was a Young Man), about Dresden.

On June 23 2004, 59 years after the bombing of Dresden, the seemingly unachievable was finally achieved; a crane lifted a reconstructed wooden tower, complete with golden cross, back onto the cupola of the Frauenkirche. The tower and cross were donated by the British; the cross had been made by an English artist-blacksmith whose father had served on one of the bombers in the Second World War. The church now once again has its rightful place on Dresden's horizon, just as royal painter Bernardo Bellotto portrayed it in the mid-18th century. The mound of rubble where the church once stood was scheduled for disposal when the quick-witted preservation lobby stepped in, persuading the local authorities to leave it standing as an official memorial to the terrors of war. Thanks to the generosity of countless sponsors the church has risen like a phoenix from the ashes since the fall of the Berlin Wall, its exterior now checked with light new and dark original blocks of sandstone, a poignant tapestry of the past and the present. Painstakingly restored, Dresden now takes centre stage with its show of electoral Renaissance and royal baroque, mingled with Socialist functionalism; of neoclassicism at the Semper Opera House, tinged with the Moorish hues of the Yenidze cigarette factory; of VW's futurist Gläserne Manufaktur (Transparent Factory), soothed by the natural landscaping of the neighbouring Großer Garten.

The area around Dresden is just as pleasing. There's Moritzburg, the magical hunting lodge of Dresden's Saxon rulers; the Sächsische Weinstraße (Saxon Wine Route) through the green and pleasant valley of the River Elbe; the magnificent scenery of the hilly Elbsandsteingebirge; Upper Lusatia with its living Sorb culture and the splendour of Meißen and Bautzen – not forgetting Görlitz, the "pearl of Lusatia". You can now walk across the River Neisse or Nysa to Zgorelec in Poland in the old eastern block, unhindered by border guards. The national boundaries near Zittau, too, are no longer manned; instead, Germany, the Czech Republic and Poland are strengthening their bond of partnership in a region which is truly European.

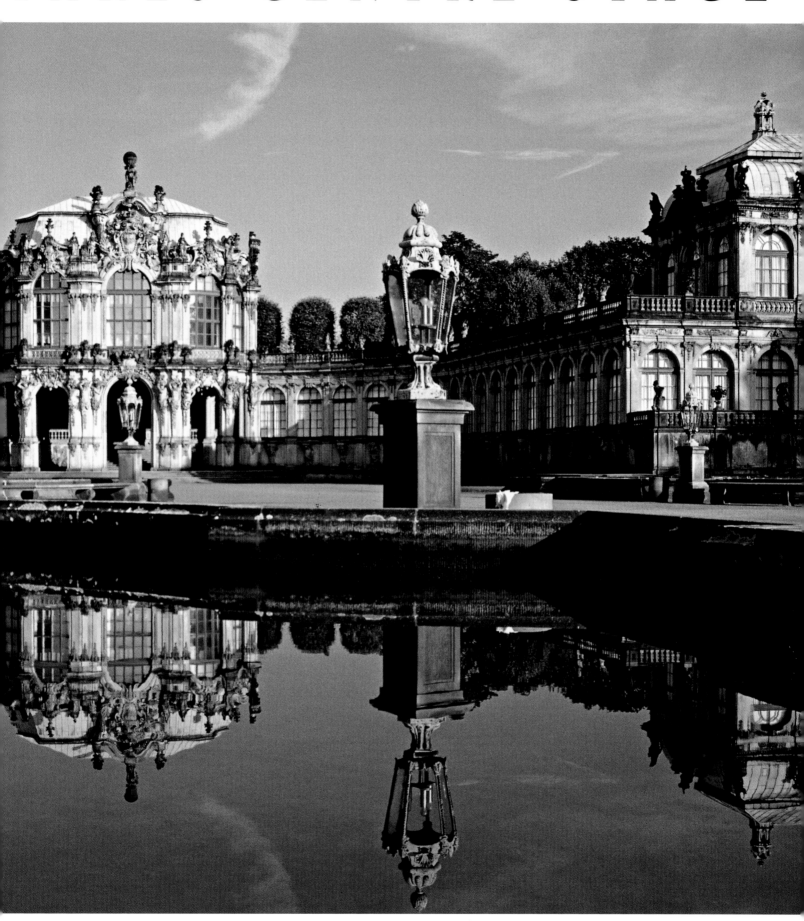

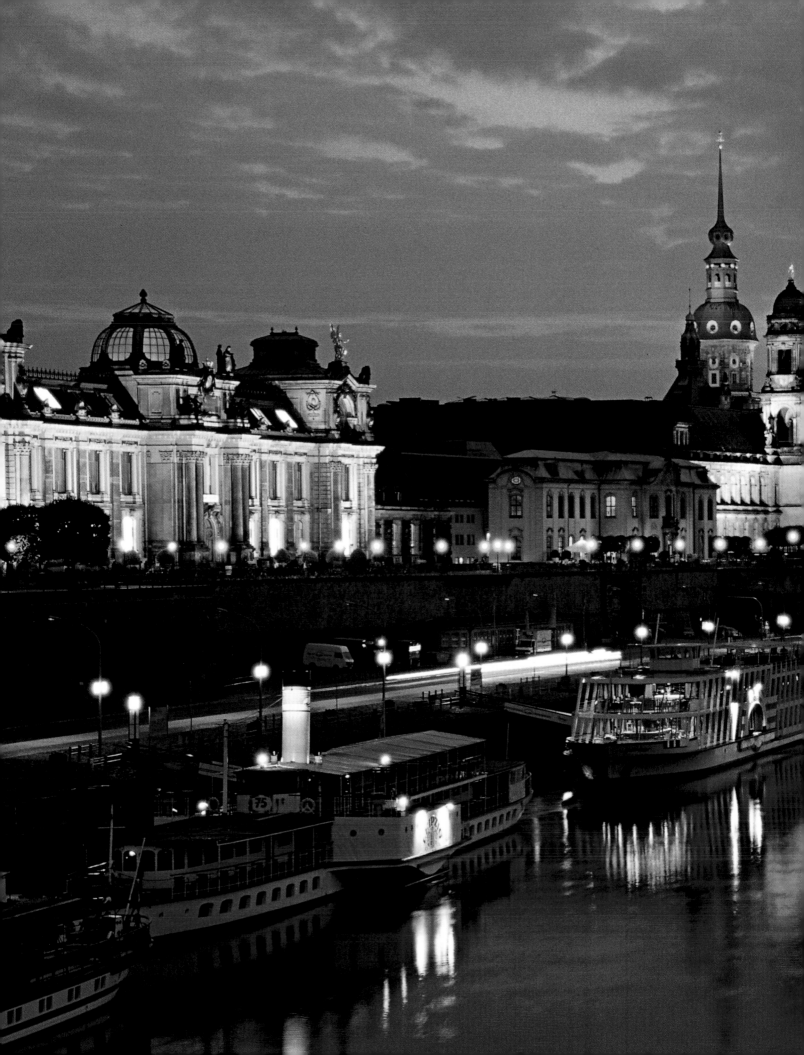

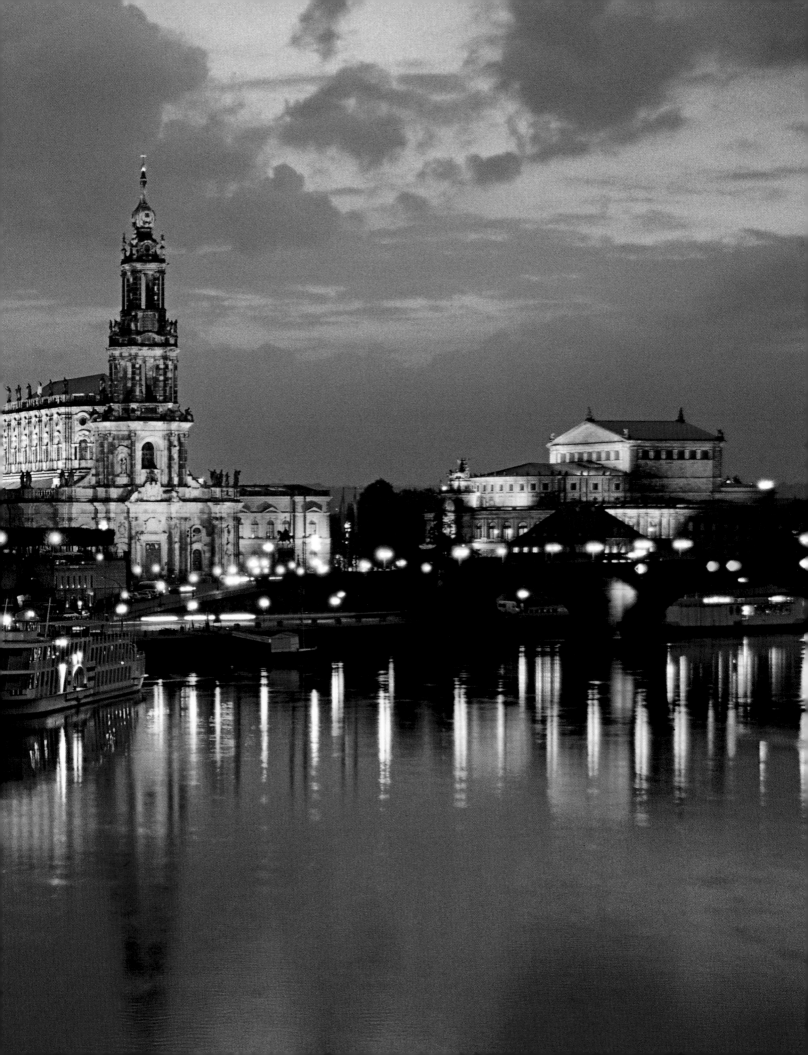

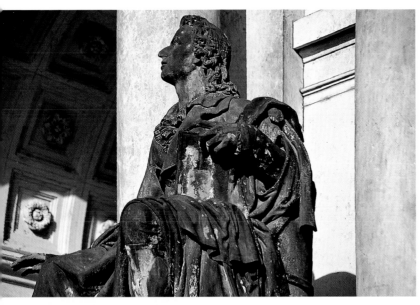

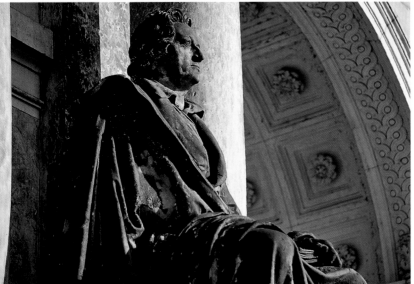

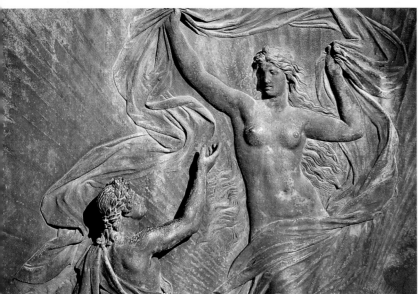

Top and centre left: Richard Wagner was made musical director of the Semperoper in 1843. He attempted to generate an enthusiasm among his audiences for German Romantic music, one of the more sensational performances being of Beethoven's 9th Symphony and "Ode to Joy". Busts of Schiller and Goethe flank the main entrance.

Bottom left: The Semperoper was again destroyed in the air raids of 1945 and has since been painstakingly rebuilt.

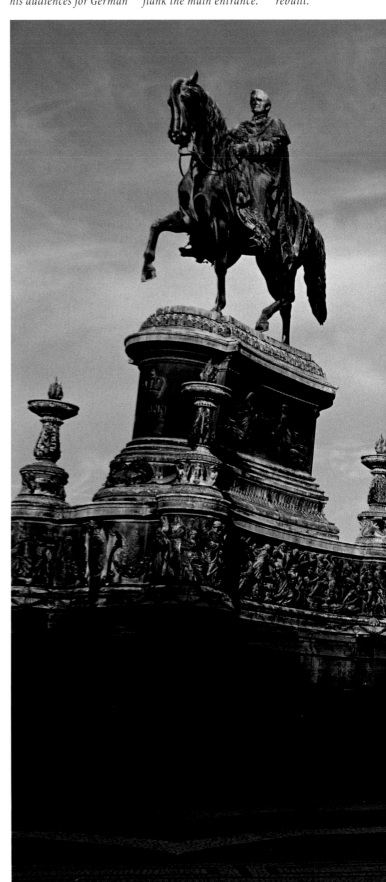

Below:
On October 7, 1989, tens of thousands stood up for their rights outside the opera house on Theaterplatz. Inside the hall was buzzing to the strains of "Fidelio" which featured a controversial set of barbed wire and pseudo Berlin Wall. Beethoven's tale of the triumph of bravery and loyalty over the despotism of the state proved extremely topical.

Page 28/29:
Dresden. Magically majestic, the city lies embedded in a romantic river valley, its impressive silhouette the source of inspiration for many a poet and painter. The mighty sandstone Augustusbrücke straddling the Elbe links the famous baroque left bank to Dresden-Neustadt, the new town erected in place of Old Dresden after it was destroyed by fire in 1685.

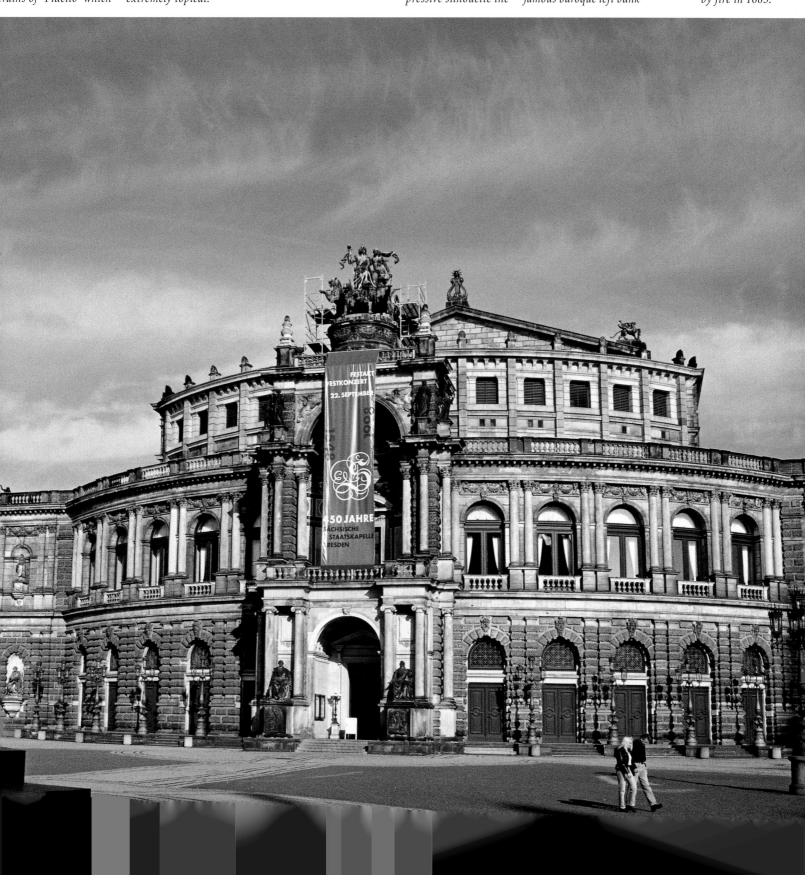

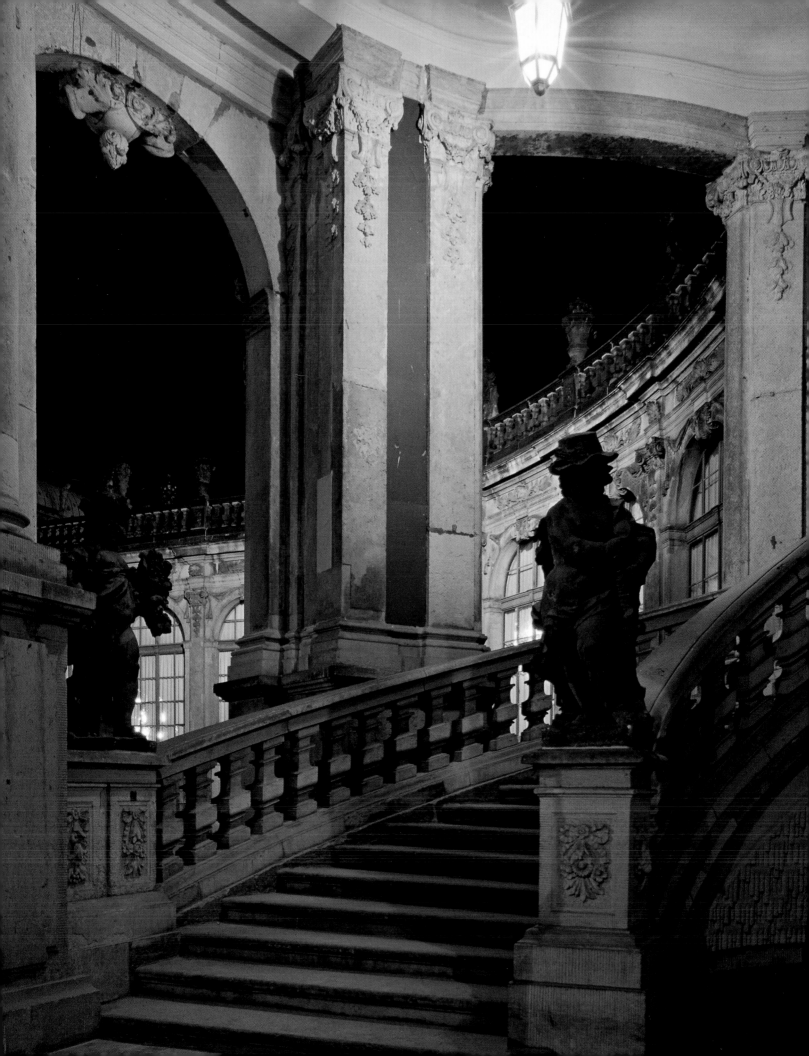

ft:
ushed by the robes of
ose making a grand
d showy entrance,
andiose baroque stair-
ses such as this one in
e Zwinger perfectly

pandered to the desire
for pomp and represen-
tation rife among the
members of the court
of king and elector
Augustus the Strong.

Below:
The Zwinger seems to be
a particularly harmo-
nious ensemble – all the
more remarkable when
you consider that it was

not designed as a com-
plete entity but built in
several stages as funds
became available. It was
an impressive venue for
grand outdoor festivi-

ties, such as the first in
1719 when the heir to
the throne married the
daughter of Emperor
Joseph I, Maria Josepha.

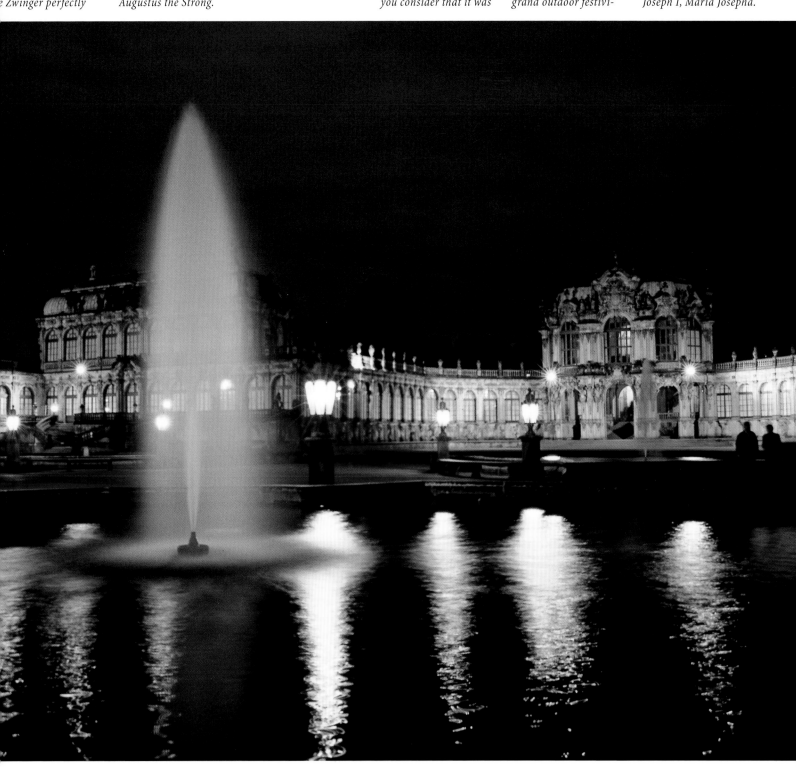

Behind the French Pavilion is the Nymphenbad, an enchanting grotto of water nymphs arranged in decorative niches begun in 1711. The nymphs were fashioned by widely travelled sculptor Balthasar Permoser who also designed the magnificent figures in the Zwinger. A native of Bavaria, Permoser worked in Rome, Venice and Florence before Elector John George III took him on as his court sculptor in 1689. Under his son Augustus, himself a passionate lover of Italian art, Permoser developed a language of form which combined the spirit of the Mediterranean with that of Dresden.

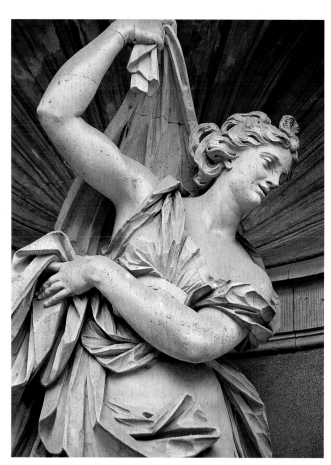

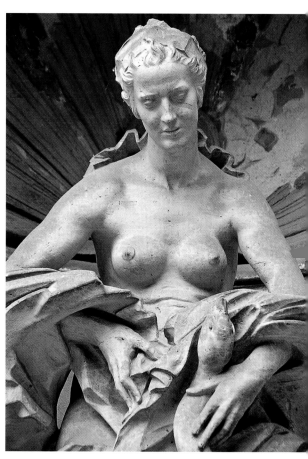

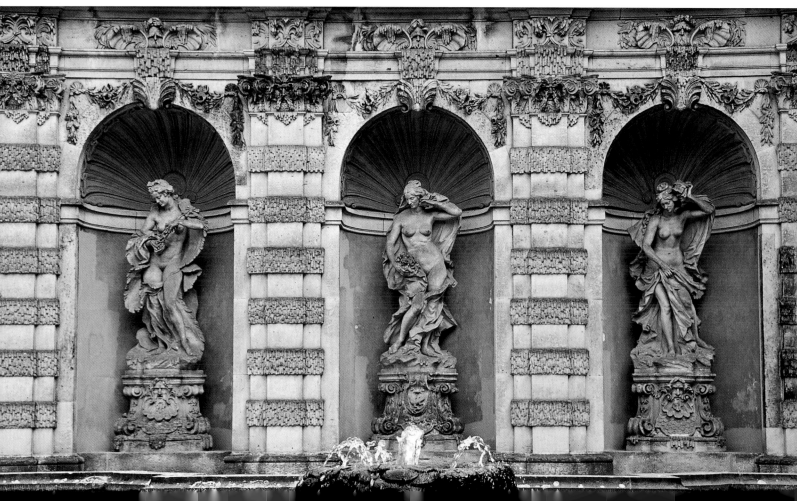

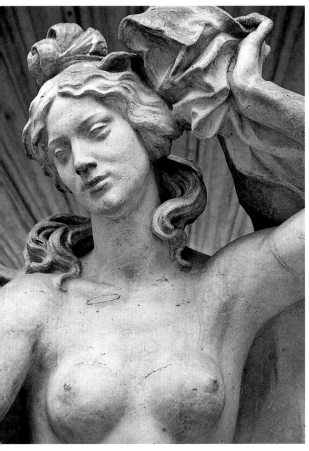 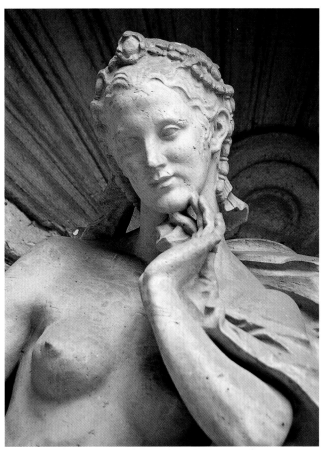

Far left and left:
Augustus the Strong was probably not the only man to have gone weak at the knees on clapping eyes on this stone beauty... He was something of a hunter-gatherer – and not just of the fairer sex. Like his ancestors before him he collected Asian porcelain, stocked the electoral armoury with weapons of the finest calibre and filled the treasury of scientific instruments with state-of-the-art inventions.

Below:
The stone figures poignantly poised in their monumental niches seem to harbour secret smiles when the fountains playfully spurt jets of crystal-clear water up into the air. Truly baroque in design and spirit, a smart symbiosis of sculpture and nature, the grotto provides much amusement to visitors.

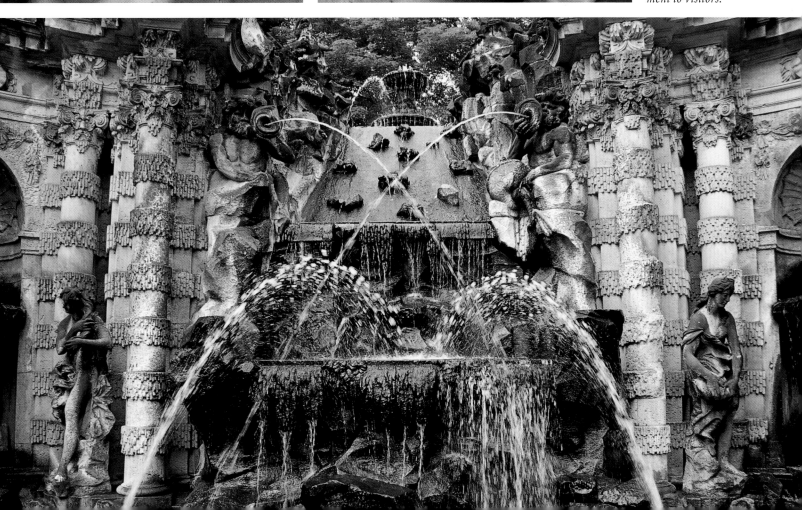

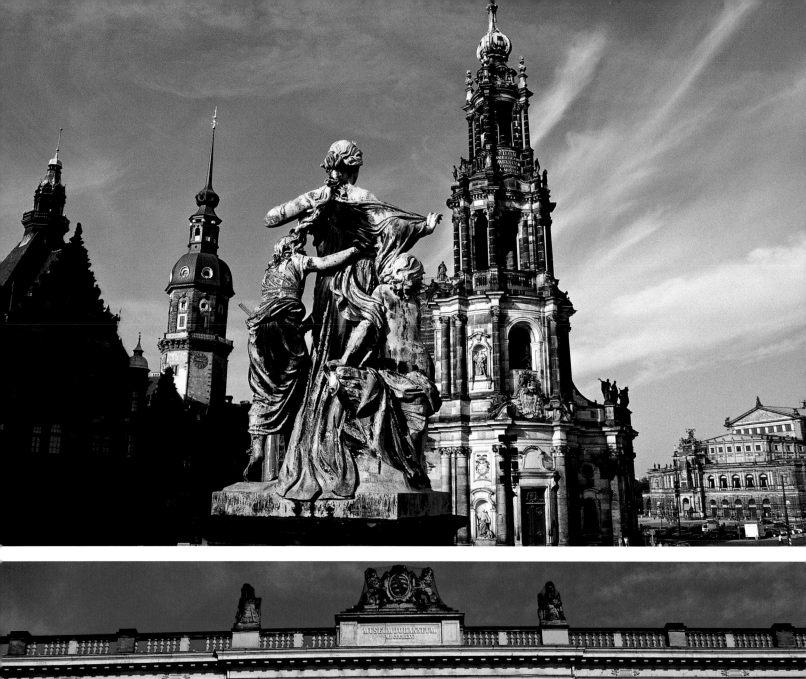

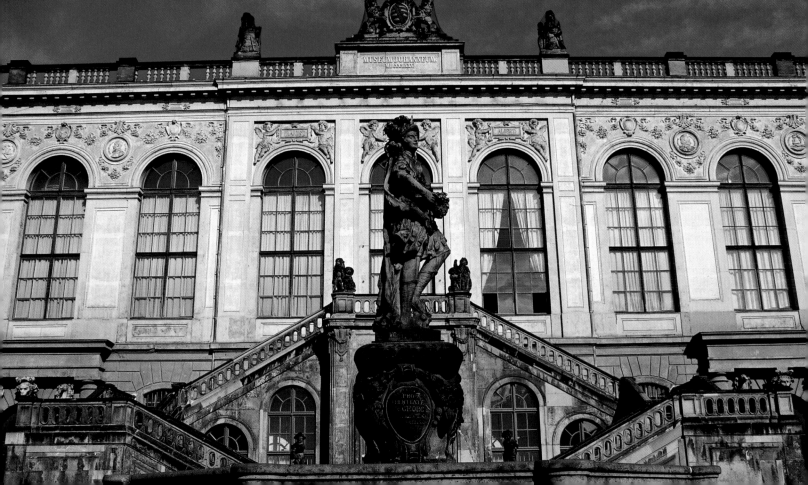

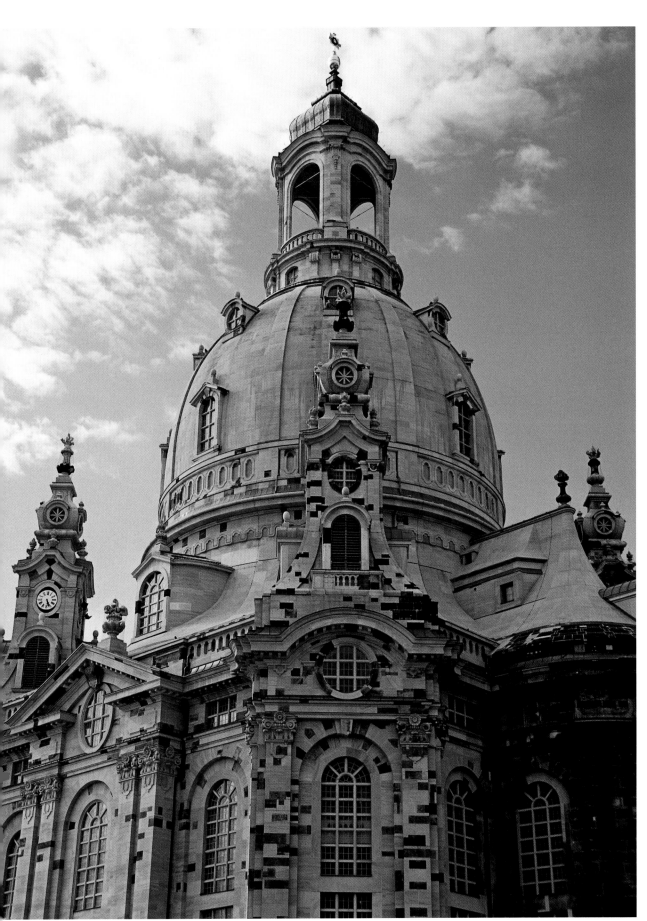

Top left page:
The Brühlsche Terrasse
was named after Saxon
minister Count Heinrich
von Brühl who was given
the river bank as a present
during the 18th century.
He promptly had it turned
into a private pleasure
garden. On being opened
to the general public it
was rather exuberantly
known as the "balcony of
Europe". Today the terrace
is still a very pleasant
place to stroll along and
enjoy the magnificent
views of the Semperoper,
Hofkirche (court chapel)
and Residenzschloss
(residential palace).

Bottom left page:
Augustus the Strong had
one of the stables of
Dresden's Residenzschloss
turned into an art gallery.
His son continued to
build up the collection.
In 1856 the paintings were
moved to the Semper-
galerie in the Zwinger
and the building, named
the Johanneum after the
reigning king, turned
into a museum of history.

Left:
It wasn't a royal architect
but Dresden's master
carpenter, George Bähr,
who drew up the plans
for the impressive Frauen-
kirche. Building began
on the neo-Florentine
Protestant church with
its wide cupola in 1727.
The mighty edifice with-
stood the canons of
Frederick II's army dur-
ing the Seven Years' War
but succumbed to the
heavy air raids of Febru-
ary 1945, collapsing in a
heap of rubble. It has
since risen like a phoenix
from the ashes in time
for Dresden's 800th
anniversary in 2006, its
glorious resurrection
funded by donations
from all over the world.

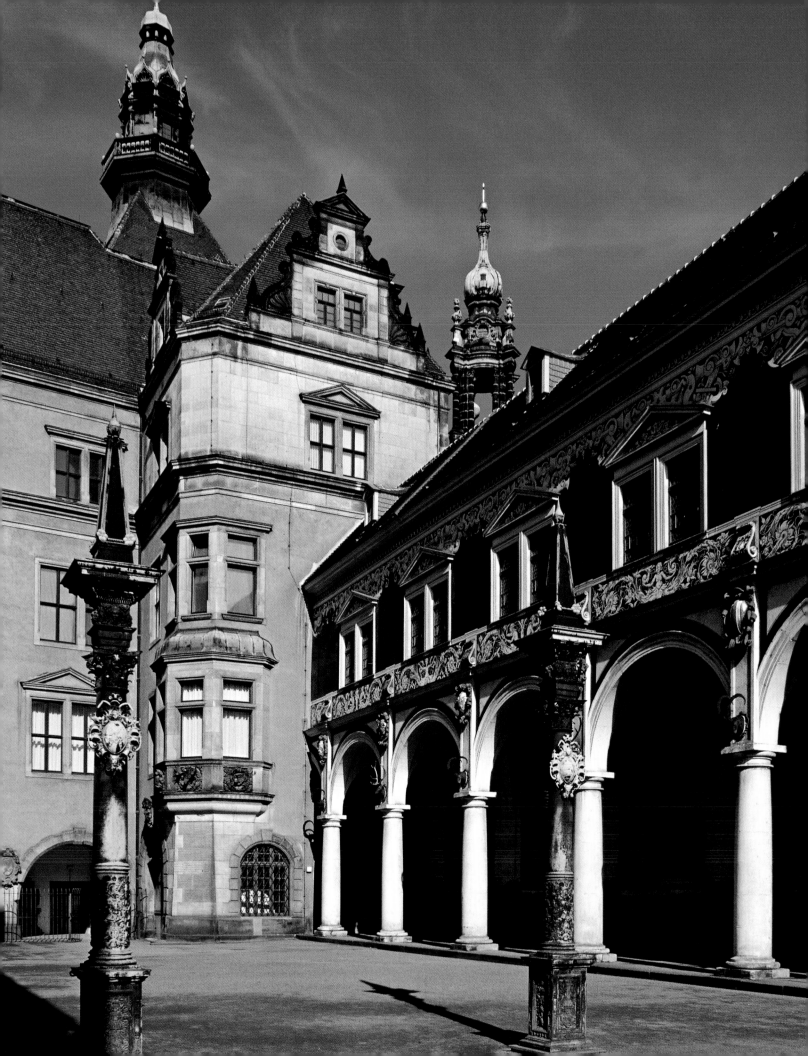

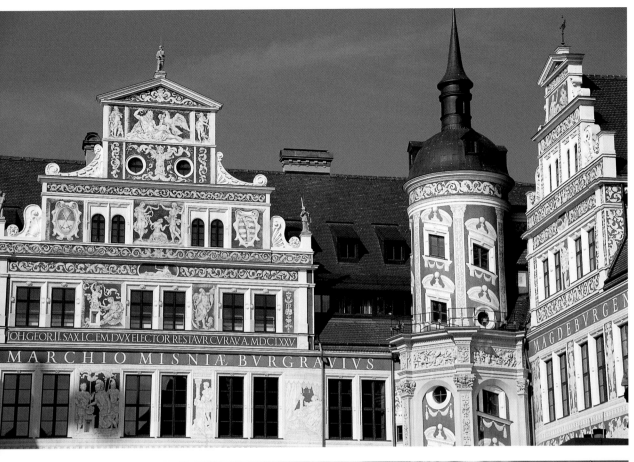

Left page:
The Tuscan arches of the
Langer Gang run along
the Stallhof or old stables
of Dresden's Schloss.
The long courtyard, one
of the oldest jousting
venues to have been
preserved, was where
royal tournaments were
held. A special ramp
allowed competitors
to ride straight up onto
the first floor.

The medieval castle
which once stood on
this site was refurbished
during the 15th and
16th centuries to provide
the Wettin dynasty
with one of the finest
Renaissance residences
in Germany. It was
destroyed by bombs in
1945. The replica palace
now shines in all its
former glory.

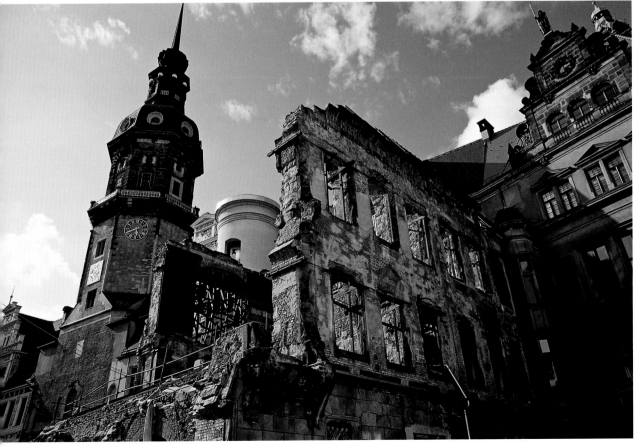

The rebuilding of
Dresden's gutted residen-
tial palace began four
decades after its destruc-
tion, ready for Dresden's
2006 centenary. From
the balustrade of the
Hausmannturm there are
grand views out over
the city and surrounding
area.

A native of West-phalia in the west of Germany, Matthäus Daniel Pöppelmann was made master builder and royal architect to Augustus the Strong in 1705. To help him gain inspiration for the building of the Zwinger, in 1710 the elector sent him to Prague, Vienna and Rome and in 1715 to Paris.

When Frederick Augustus was born in 1670 his life was already mapped out before him. His older brother Johann Georg would one day ascend to the throne and he, the second oldest, was destined for a career in the military. When they were teenagers his effervescent father, a great lover of art, packed them off on an aristocratic Grand Tour to Europe's centres of art and power, introducing the boys to the artistic treasures, customs and traditions of their neighbours

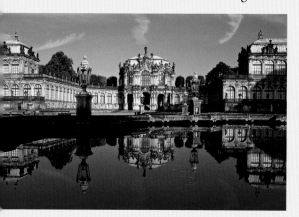

and allowing them to let their hair down a bit before the serious business of life as an adult royal began. Frederick Augustus revelled in the Carnival of Venice but proved less adept in the ballrooms of Paris than his older brother who was a master of both the dance and the small talk this necessitated. The Sun King nevertheless lavished much attention on the quiet 17-year-old. The young man for his part was overwhelmed by the splendour of the French court, by the magnificence of the palace at Versailles and by the aura surrounding France's absolutist ruler. He found himself wanting to be very much like this rich and remarkable man.

In 1694 his brother, the young Elector Johan Georg IV, suddenly died of smallpox, leaving Frederick Augustus the throne. Physical strength, obstinacy, cunning and sheer domination of character soon earned him the epithet of Augustus the Strong. His political agenda was ambitious. Alongside Austria and Brandenburg-Prussia he planned to make Saxony one of the great regional powers and a major player on the European stage. Two years later the Polish king died; Frederick Augustus promptly applied for the post. His chances of success were very slight. The board of Polish aristocrats who were charged with electing the new king were not short of candidates and as a Protestant the elector could not be king of a Catholic country. Frederick Augustus pulled out all the stops. He sold off some of Saxony's hoard of treasure and also various estates and trading rights, using the profits to ingratiate himself with the blue-blooded electorate. He even converted to Catholicism – as head of the state which had given birth to the Reformation. His actions unleashed a storm of anger in Saxony which the elector dispelled by promising religious freedom for all. He was crowned Augustus II, king of Poland, in Cracow on September 15 1697.

AN ARTISTIC DREAM TEAM

The seat of power and place of residence of the new elector-king was to be his native Dresden – once he had made some minor alterations. He wanted the modest town on the River Elbe to become a brilliant gem of the baroque, encapsulating the magic of Versailles and the beauty of the royal Italian palaces. He engaged an artistic dream team to realise his vision: the architect was Pöppelmann, the sculptor Permoser and the goldsmith Dinglinger. Their creations were a masterly combination of the cultural heritage of Europe and the playful spirit of Saxony: the Zwinger and Taschenbergpalais, the palaces of Moritzburg and Pillnitz, the Kleinodienmuseum in the Grünes Gewölbe (Green Vault), the Augustusbrücke, Großer Garten and Japanisches Palais. The bill was presented to his minions in the form of heavy taxes.

Right up into old age Augustus the Strong had one weakness – namely for the fairer sex. Countless illegitimate children were said to have been fathered by him; some estimates run to at least several dozen. Countess Anna Constantia Cosel, both beautiful and highly

Top far right:
Usually depicted as a distant and unapproachable monarch, Permoser's sandstone composition of the Saxon elector-king portrays Augustus the Strong as an accessible and worldly-wise human being. The work was destroyed in 1945.

Right:
The Zwinger is the result of a close collaboration between architect Matthäus Daniel Pöppelmann and sculptor Balthasar Permoser. One of the pair designed the famous Kronentor or crown gate, featuring a gilt royal headpiece borne by four Polish eagles, and the other the statues of the four seasons adorning the niches of the gatehouse.

Left:
Perhaps the best example of the perfect symbiosis of Pöppelmann and Permoser is the Wall-pavillon whose wonderfully ornate figures are reflected in the water of the grand basin. The pavilion is crowned by a Saxon Hercules: Augustus the Strong manfully bearing a sculpted globe.

Bottom far right:
The back of the white marble image of the Suffering of Christ in Dresden's Hofkirche bears a portrait and the following inscription: "Balthasar Permoser made this in Salzburg in his 77th year, 1728".

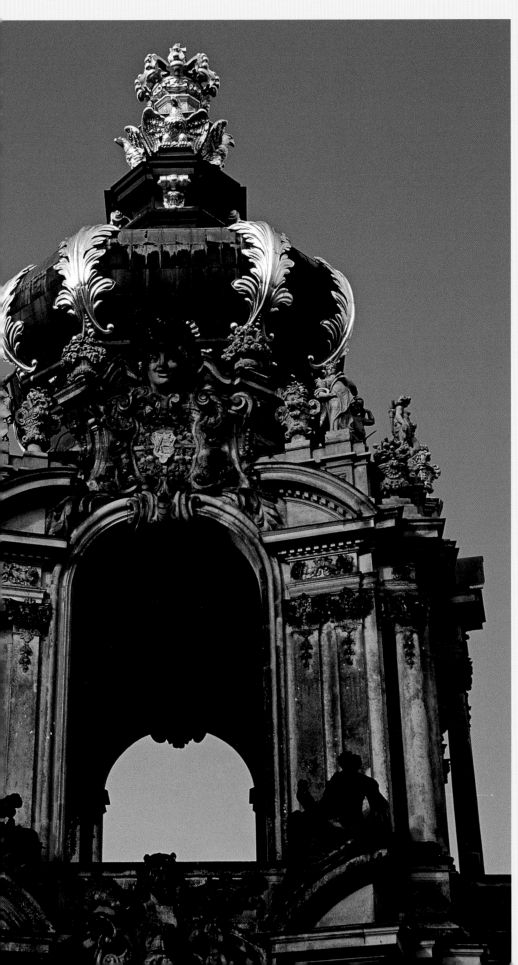

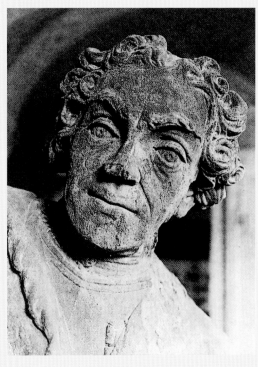

educated, was a good rider and a hardened drinker. She bore Augustus three children and for nine years was the royal favourite and an influential confidante. When an attempt was made to remove her from court in favour of a new mistress she pulled a marriage contract secretly signed by Augustus from under her petticoats and threatened to shoot the elector if he left her. Her unfaithful lover wasn't perturbed; he had his rebellious countess spirited away to the impenetrable fortress of Stolpen where she remained until long after his death. His only legitimate son, Frederick Augustus III, followed in his father's footsteps and was both elector of Saxony and king of Poland from 1733 to 1763. His death marked the end of the Augustinian Period and almost seven decades of political astuteness and artistic creativity for Saxony.

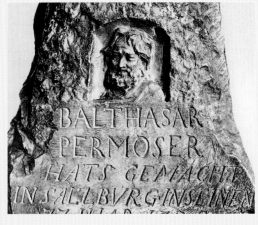

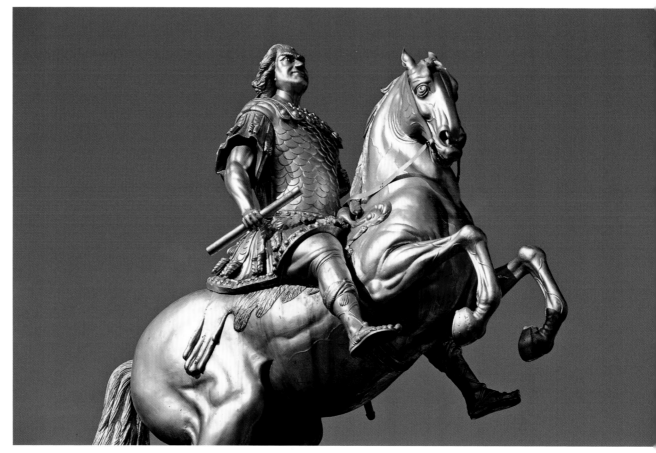

The golden rider statue on Neustädter Markt on the right bank of the Elbe was fashioned after Augustus the Strong's death and shows him in Roman armour, his gaze firmly fixed on the opposite bank of the river with his Schloss and Zwinger, his centres of worldly power and cultural intellect.

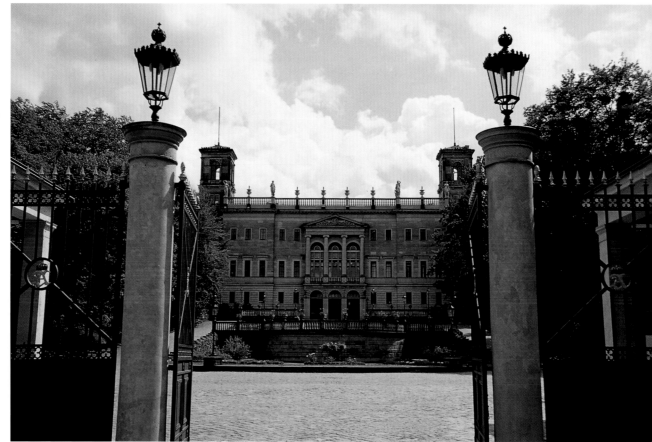

Schloss Albrechtsburg on the slopes of the River Elbe affords marvellous views out across the Saxon capital. The sandstone palace was built in the mid-19th century for Prince Albert of Prussia, with architect Adolph Lohse taking the villas of the Italian Renaissance as his model. Two square campanile-type towers flank the main facade, softened by a large pillared bay at the centre.

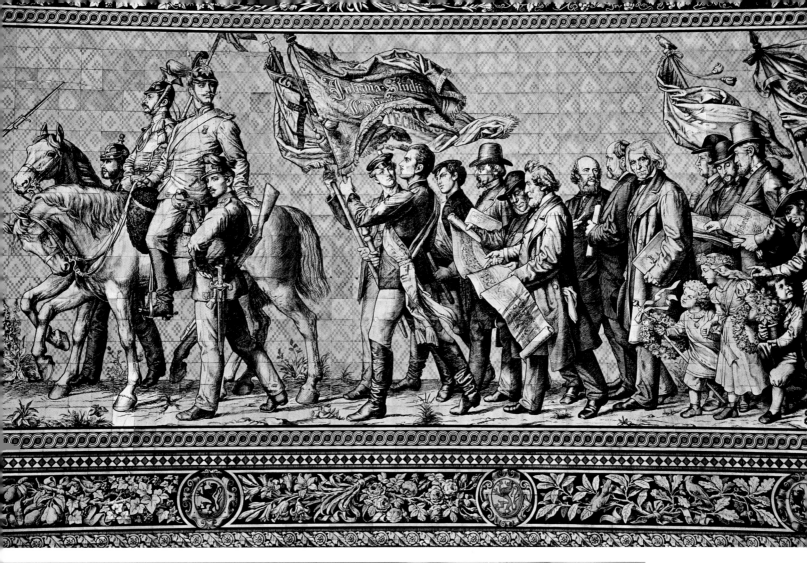

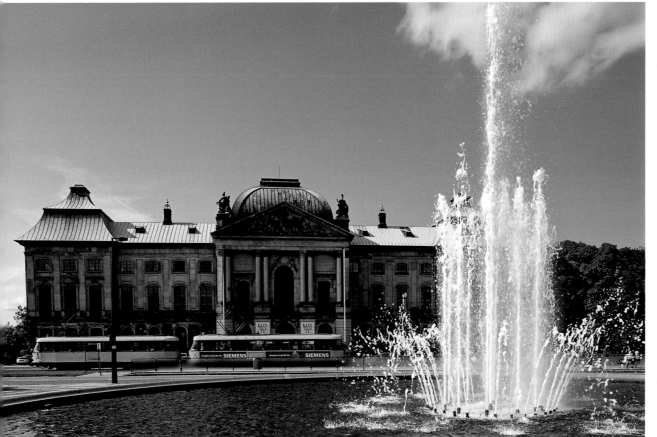

102 metres (335 feet) long, the Fürstenzug frieze running along the outer wall of the Langer Gang is made up of 25,000 Meißen porcelain tiles. No less than 93 people are included in the procession.

Left:
Augustus the Strong bought the Dutch envoy's palace on the Elbe and under Pöppelmann's capable direction had it extended and turned into the Japanisches Palais. Oriental elements were incorporated into the baroque-cum-neo-classical design in keeping with the current fad for all things Asian. The elector also intended to exhibit his collection of Chinese, Japanese and Meißen porcelain here.

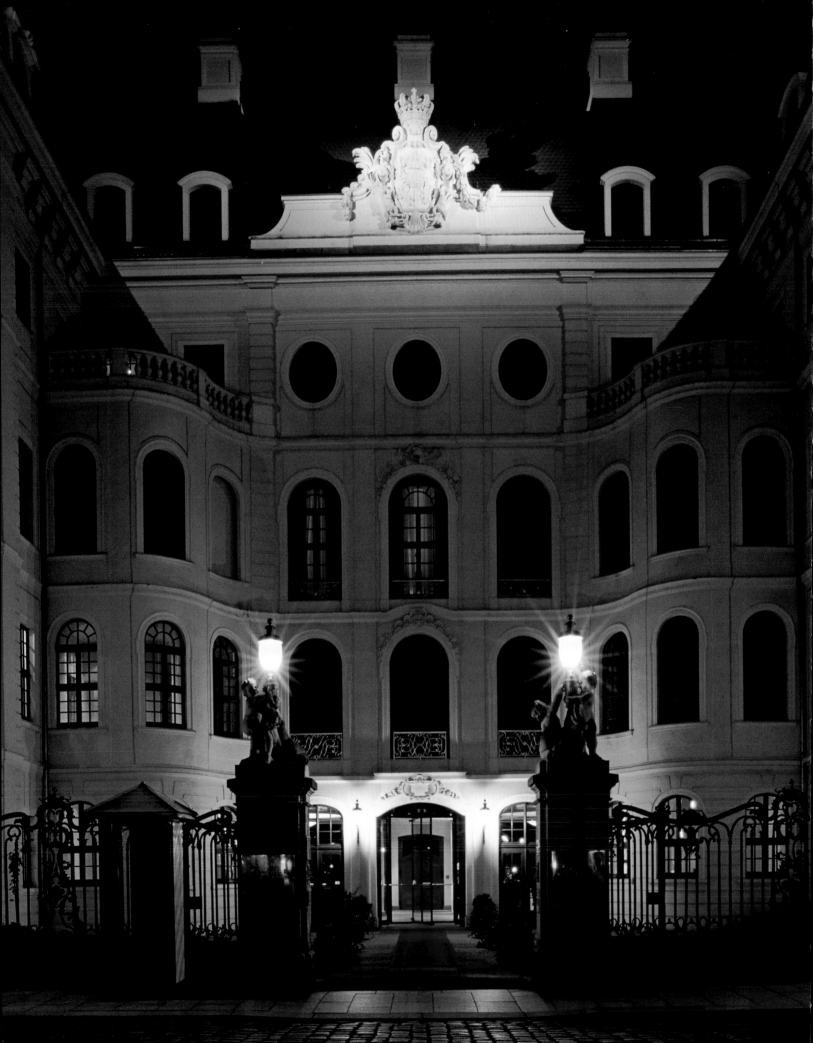

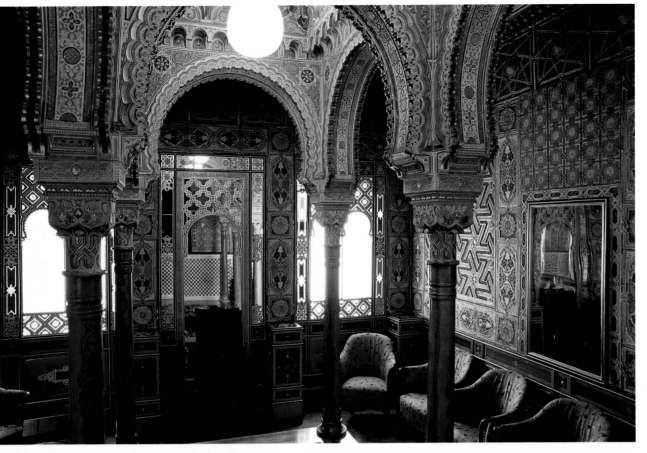

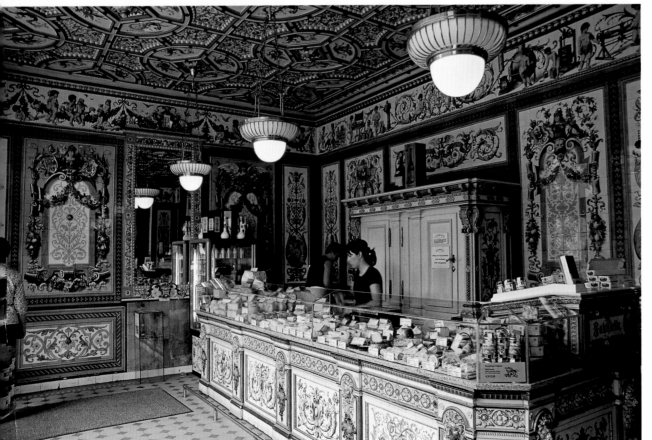

Left:

It was customary for the
architecture of the 19th
century to "borrow" from
past epochs, producing
colourful and often
idiosyncratic mixtures of
historical styles. Schloss
Albrechtsburg is no
exception, with the clear
neo-Renaissance lines of
the facade contrasting
starkly with the exces-
sively ornate tiling of its
Turkish bath.

Left page:

The Taschenbergpalais
next door to the Resi-
denzschloss was origi-
nally built for Countess
Anna Constantia Cosel,
for years Augustus the
Strong's favourite and
the mother of three of
his children. When she
insisted on him honour-
ing his written proposal
of marriage, he had
her locked up in the
fortress at Stolpen and
took a new mistress –
Countess Marie Dönhoff,
the daughter of Grand
Marshal Bielinksi of
Poland, perhaps in a
calculated attempt to be
nearer to the Polish
crown...

Left:

Opened in Dresden-
Neustadt in 1892, Pfunds
Molkerei is possibly the
most luxurious dairy
shop in the world. Tiles
handmade by the Dresden
pottery Villeroy & Boch
adorn the ceiling and
counter. The floor, too,
is also lavishly tiled. The
shop still operates, sell-
ing a range of top-quality
cheeses, with a pleasant
café and restaurant on
the first floor.

Below:
Completed in 1912, Yenidze was once a cigarette factory and is one of the first industrial buildings in Germany to be made of reinforced concrete. Moorish features mingle with playful elements of Jugendstil; the slim minaret towers flanking the bulbous dome mask chimneys and ventilation shafts. The building caused an uproar among the general public and precipitated designer Martin Hammitzsch's exclusion from the country's imperial chamber of architects.

Top right:
The Historicist Königliche Kunstakademie (Royal Academy of Art) on the Brühlsche Terrasse was finished in 1894.

Centre right:
Old Dresden on the right bank of the River Elbe was destroyed by fire in the 17th century and subsequently replaced by "Neustadt bey Dresden". In one of the stately baroque residences lining the main street, at the beginning of the 19th century painter Gerhard von Kügelen once received such notable guests as Caspar David Friedrich, Goethe, Körner and Kleist.

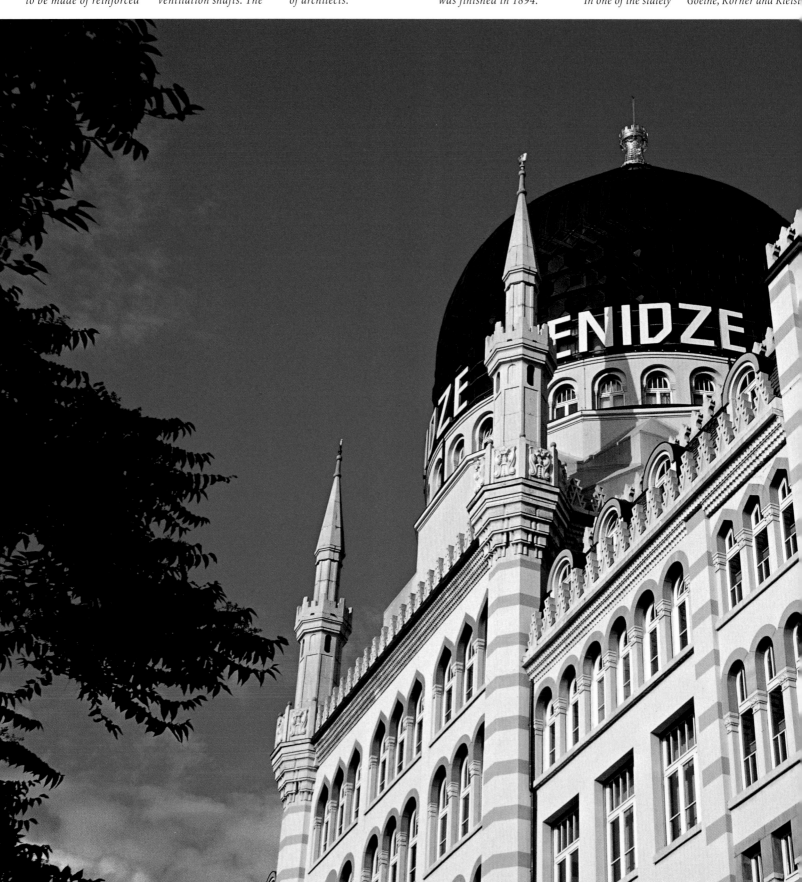

Bottom right: The four corners of the steps leading up to the Brühlsche Terrasse are guarded by statues representing the four times of the day by academy professor Johannes Schilling. At the bottom right of the steps is Night, with her cloak wrapped protectively around Sleep. The present statues are bronze casts which replaced the weathered 1868 originals just 40 years after their installation.

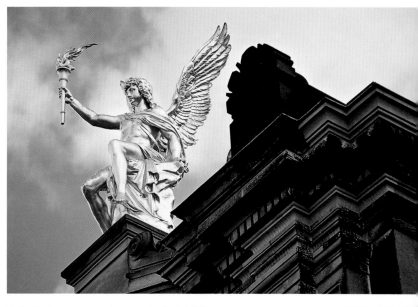

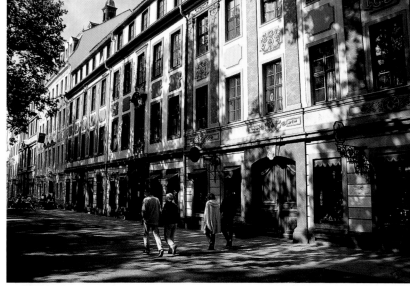

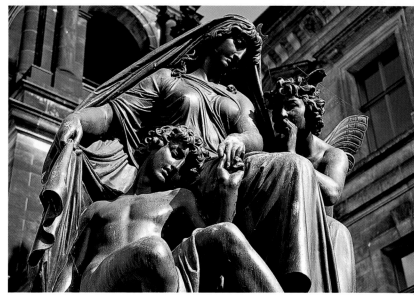

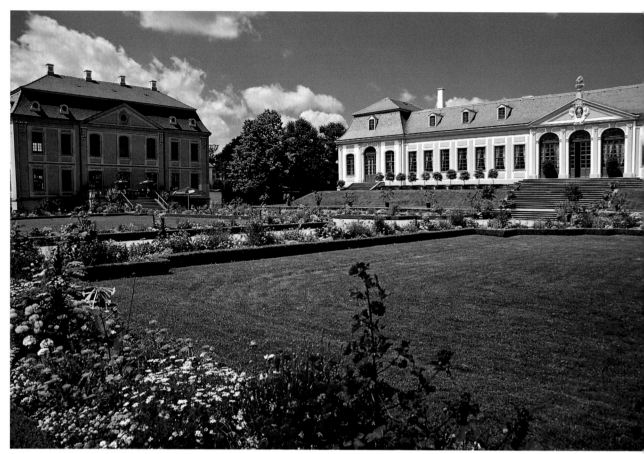

Right:
The magnificent baroque garden of Großsedlitz a few kilometres west of Pirna is the work of architectural trio Matthäus Daniel Pöppelmann, Johann Christoph Knöffel and Zacharias Longuelune.

Below:
Wide flights of steps and expansive rows of terraces, graceful statues and colourful borders lend the gardens of Großsedlitz an elegant sense of height and perspective. Visitors can enjoy a gentle stroll around the grounds which provide a fantastic backdrop for open-air theatre and concerts.

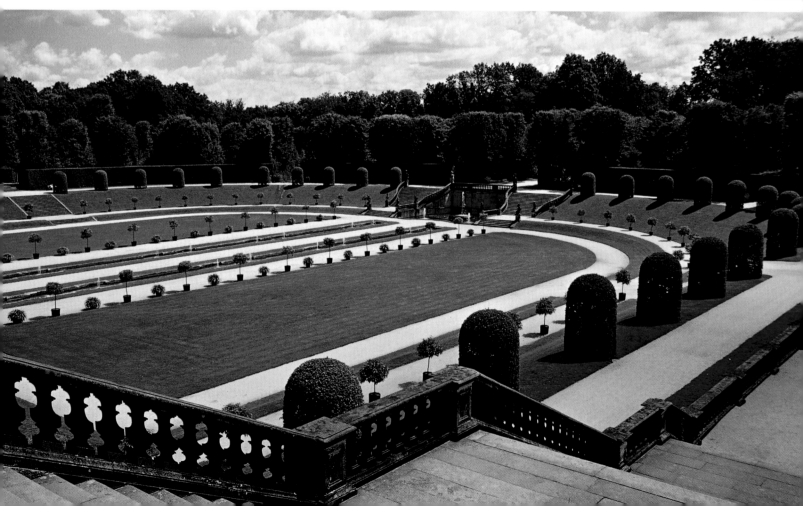

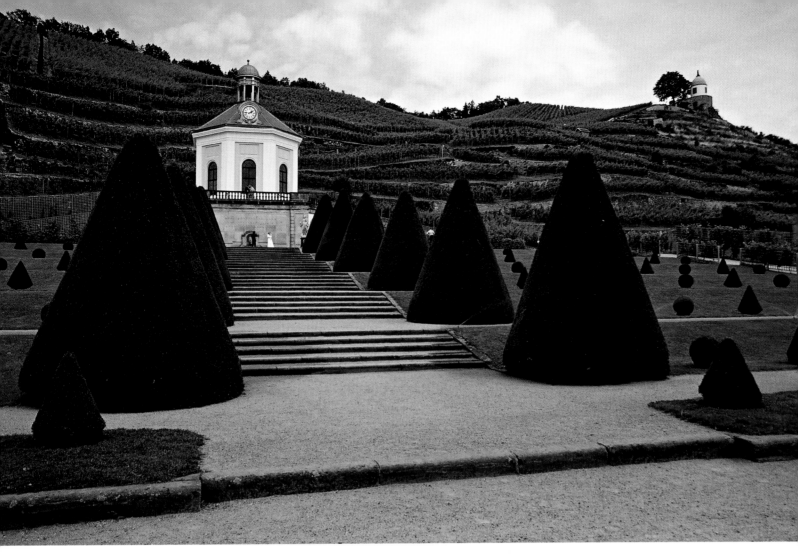

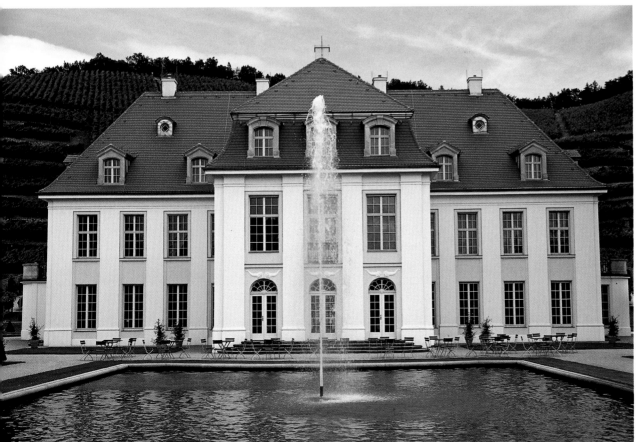

Above:
On the western edge of Radebeul on the Sächsische Weinstraße (Saxon Wine Route) lies Wackerbarths Ruh. Count Wackerbarth, former director of Saxony's building and construction industry, spent his final years here at the vineyard, probably taking a glass or two at his belvedere on the slopes of his estate on a fine evening.

Left:
Count Wackerbarth had his retirement dacha built by Johann Christoph Knöffel, one of the star architects of his electoral employer, Augustus the Strong. Schloss Wackerbarth is now a state winery and well worth a visit – especially to try some of the local wines.

Below:
Moritzburg, Augustus the Strong's impressive summer residence, gracefully resides atop a man-made island surrounded by sparkling water and lush forest. The Renaissance hunting lodge belonging to his predecessor Moritz forms the nucleus of the complex. Louis XIV, whom Augustus strove to emulate his whole life long, also had his father's hunting pavilion built into Versailles.

Top right:
The entrance to Schloss Moritzburg is guarded by two horn-blowing hunters entrusted with the supervision of the pack of hounds.

Pöppelmann was employed to manage the erection of the palace which with its four banqueting halls and ca. 200 other rooms is indeed royal in its proportions.

Centre righ
Schloss Moritzburg no holds an interestin museum of the baroqu packed with works art, various househo implements and a firs class collection

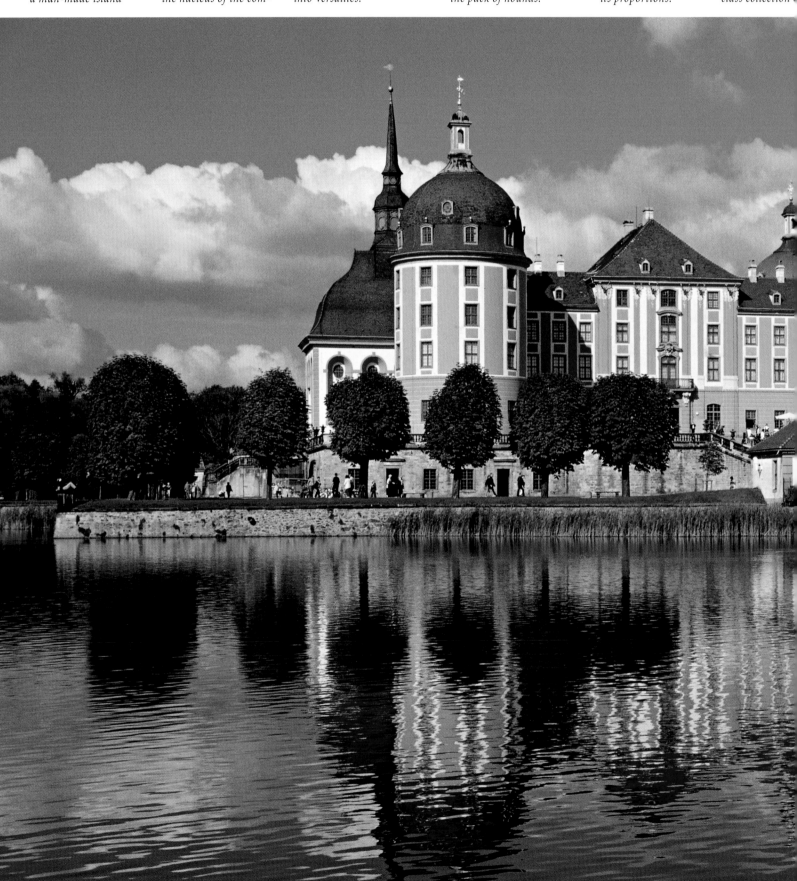

rophies. Käthe Kollwitz, probably the most significant female German painter, graphic artist and sculptor of the 20th century, died here in her Moritzburg house of Rüdenhof in 1945.

Bottom right:
The old palace hunting stables have housed Saxony's state stud farm since 1828 where cart-horses in particular were once a speciality breed. The yearly stud parades in September still draw huge crowds.

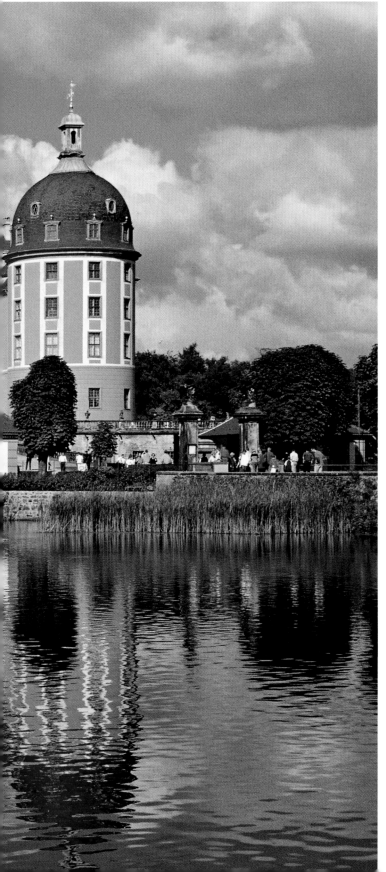

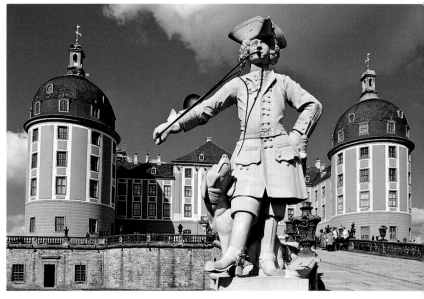

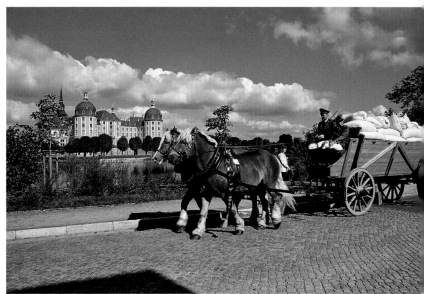

51

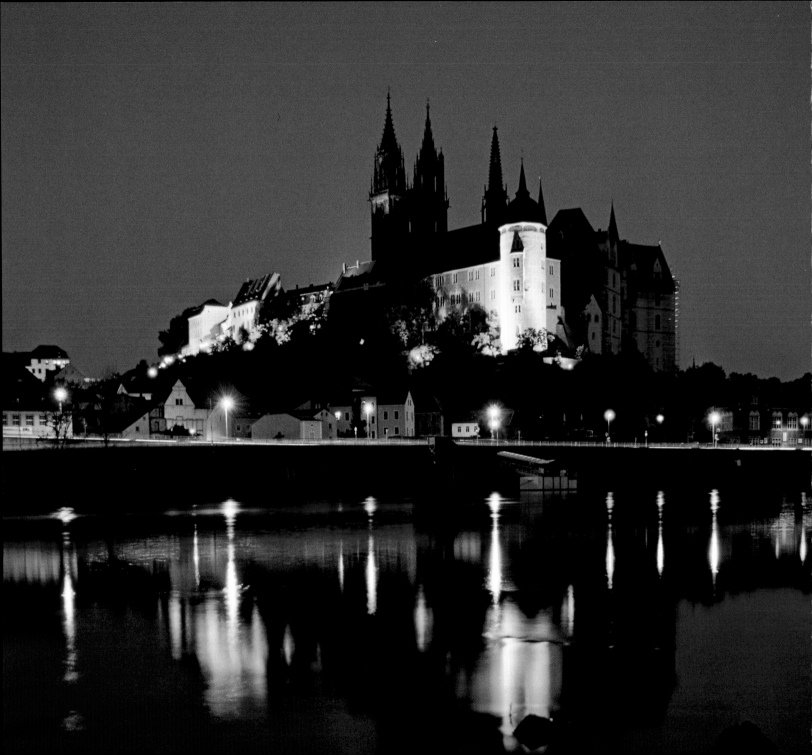

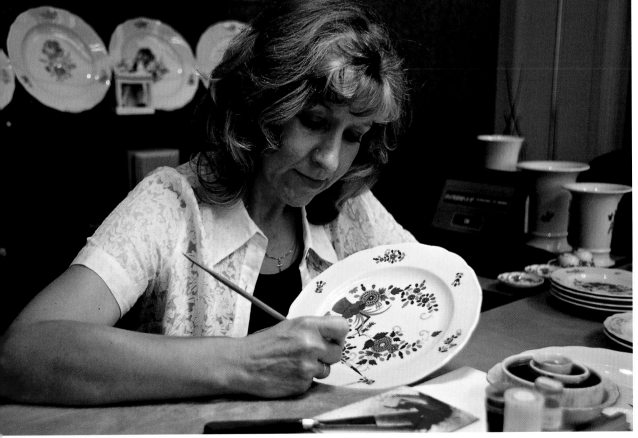

Left page:
Saxony's history began 1,000 years ago atop the castle mound in Meißen. The picturesque silhouette is dominated by the Gothic cathedral and the late Gothic Albrechtsburg, the first palace to be built in Germany. Augustus the Strong had the first porcelain manufacturer's in Europe opened here in 1710.

Left and far left:
In the porcelain museum exhibition hall at the Staatliche Porzellanmanufaktur (State Porcelain Manufacturer's) in Meißen ca. 3,000 different exhibits a year are selected for display. One of the most impressive masterpieces is this monumental centrepiece, three-and-a-half metres (11 feet) high, fashioned in 1749.

Left:
At the visitor's workshop you can study the history of the manufacturer's, learn about raw materials and techniques and follow the various stages of production. You can see how the various figures are formed and put together and how they are finished and hand painted with different patterns and styles.

Page 54/55:
Augustus the Strong gave Schloss Pillnitz to his lady companion Countess Cosel. In keeping with the fashion of the day Chinese motifs were introduced to the fantastical stylistic language of the Saxon baroque. The court travelled to Pillnitz up the River Elbe on magnificent gondolas, built by craftsmen specially brought in from Venice.

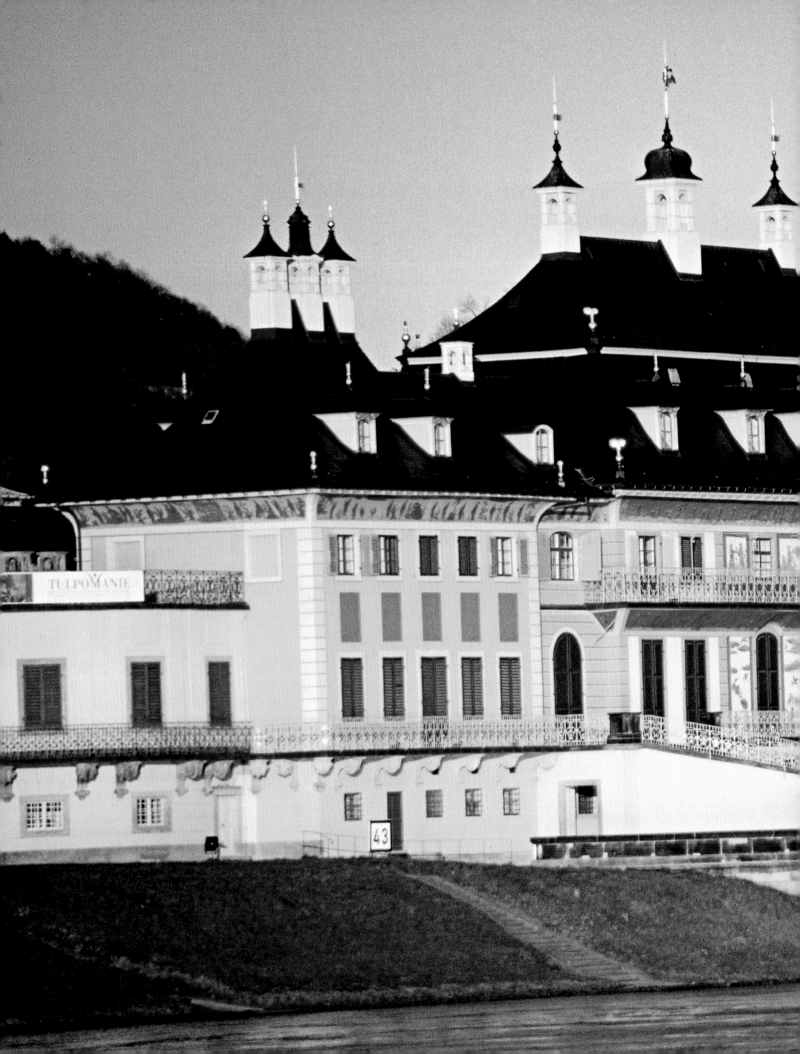

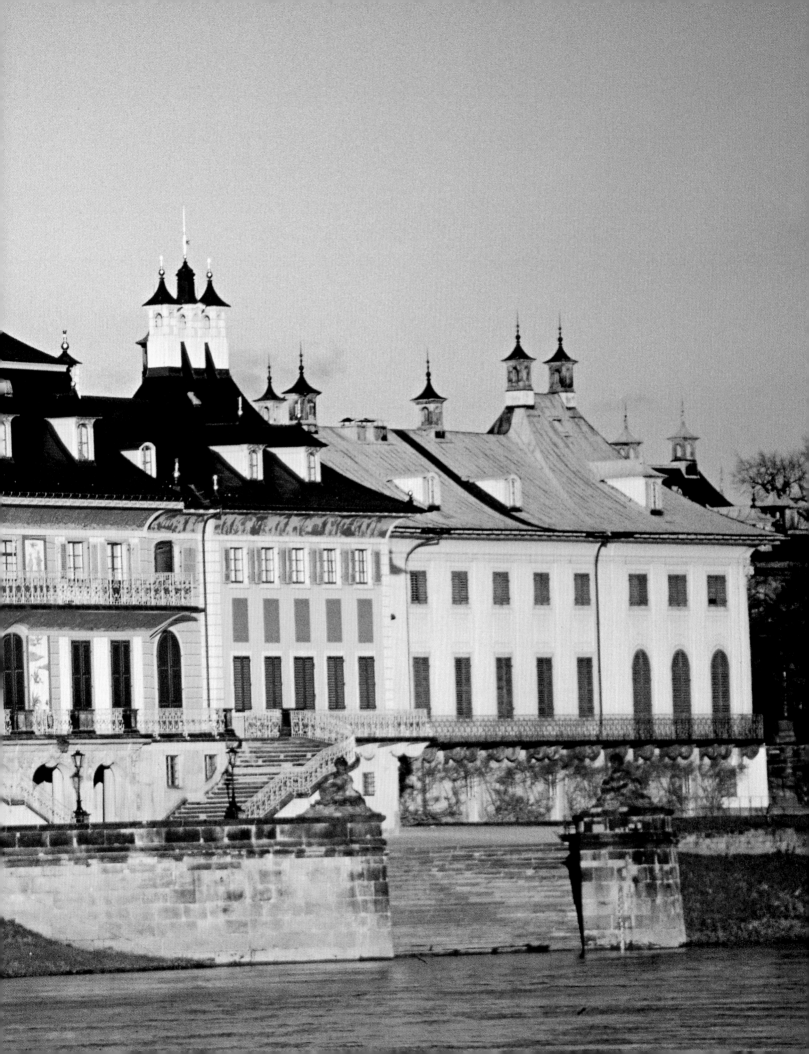

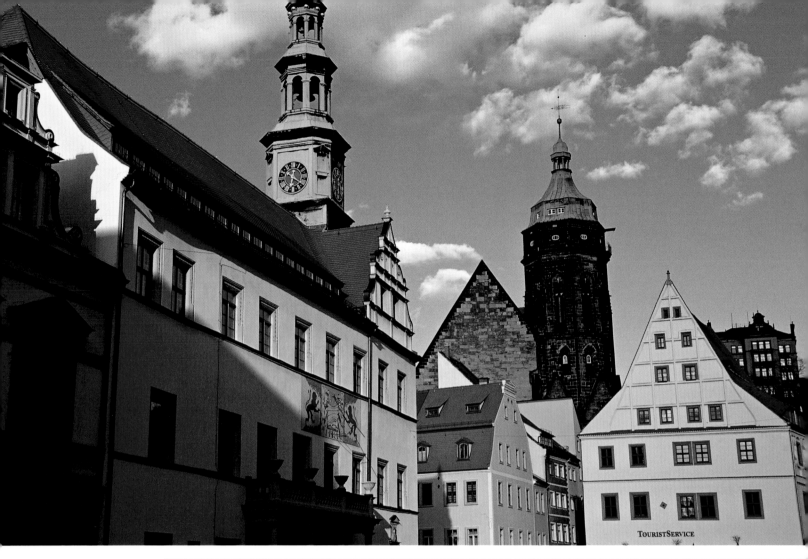

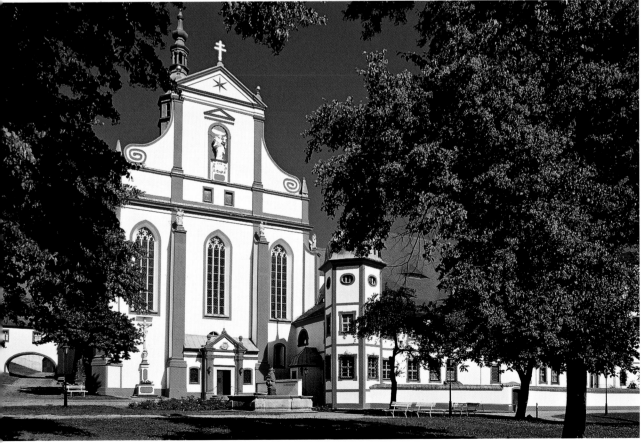

Above:
From the medieval castle of Stolpen, where Augustus the Strong had his mistress of many years Countess Cosel incarcerated while he went in search of younger blood, there are marvellous views out across the roofs of the town to the pastoral countryside beyond, sandwiched in between the national park of Saxon Switzerland and the mountains of Lusatia.

Left:
Kloster Sankt Marienstern in Panschwitz-Kuckau near Kamenz celebrated its 740th anniversary as a Cistercian convent in 2004.

57

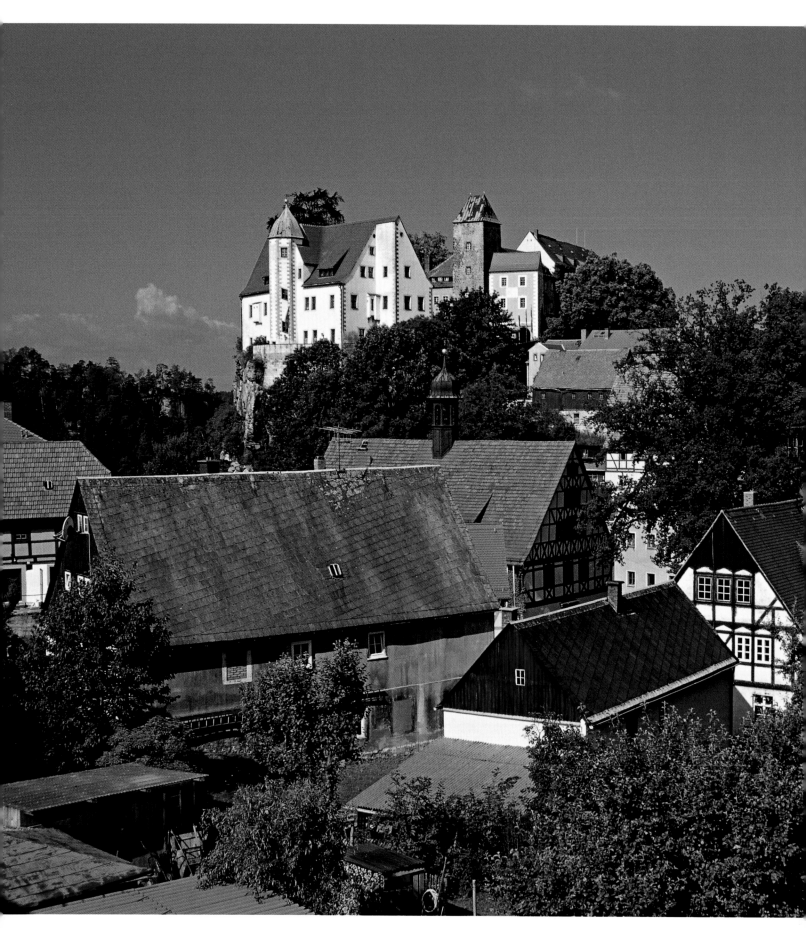

Left:
The idyllic half-timbered town of Hohnstein north of the Elbsandsteingebirge is dwarfed by the medieval castle, originally a Bohemian border post. The town rose to fame thanks to Max Jakob who from 1928 to 1945 ran his famous puppet theatre here, Saxony's answer to the British Punch and Judy Show.

Above:
At Schloss Weesenstein in the valley of the Müglitz architectural design has thrown all caution to the winds. Instead of building from the bottom upwards, over the seven centuries from the Gothic to the neoclassical the castle's powers that be have done exactly the opposite. The banqueting halls are in the attic, with the stables below them on the fifth floor; beneath these are the sumptuous private apartments. Alice in Wonderland would have felt perfectly at home here.

"STOLLEN", THE POTATO AND "LEIPZIGER ALLEREI"

Where did Schiller write his "Ode to Joy"? In Leipzig, of course, where he was treated to a warm welcome and plenty of warm Saxon hospitality. Leipzig is also where Lene Voigt, the "Saxon Nightingale", once paid homage to a common root vegetable which for over three hundred years has thrived throughout the land and inspired generations of cooks to come up with a bevy of imaginative uses for it. Whether grated, boiled, mashed, chipped, fried, steamed or "au gratin", with the staple potato you can make much of very little. Voigt made much of it indeed; in addition to her successful cookery book she also penned an ode to the potato in her native Saxon dialect which would have had Sir Walter Raleigh turning in his grave …

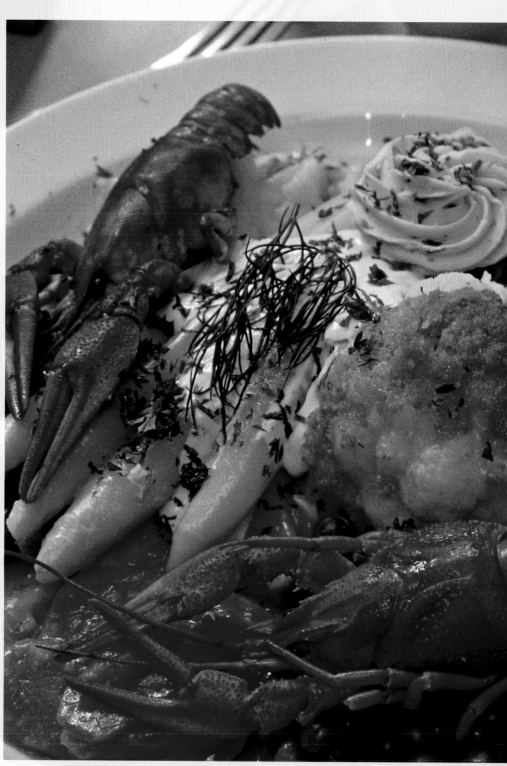

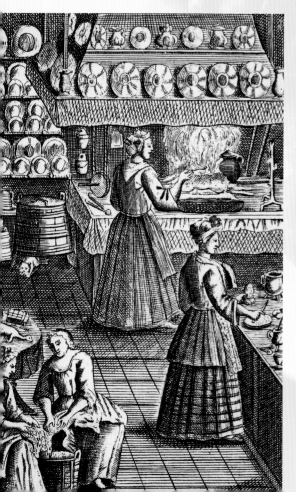

Left:
The "Leipziger Koch-buch" was first published in 1745 with this frontispiece. The author of the cooks' bible was Susanna Eger.

Above:
Delicious vegetables, fresh herbs, gourmet dumplings, morel mushrooms, melted butter and a creamy sauce topped with scampi instead of the traditional crayfish are the mouthwatering ingredients of "Leipziger Allerlei", a tasty local dish.

Top right:
"Dresdner Eierschecke a quark gateau, has yeast dough or short crust pastry base under a layer of quark, suga

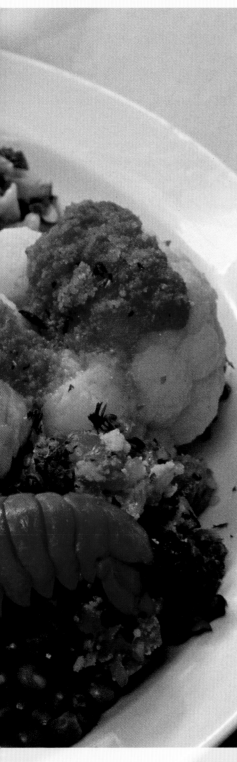

In Saxony the potato is manifold. Its use is not limited to the savoury; it's also found in a traditional dessert called "Quarkkäulchen". Mashed with quark, sugar, lemon peel and sultanas, the potato mix is kneaded to a dough and rolled into small buns which are baked until golden brown on both sides. Sprinkled with sugar and cinnamon and served with stewed fruit or sugared berries, "Quarkkäulchen" are a hot favourite.

CULINARY HERITAGE

The Saxons like their food both mild and hot, sometimes plumping for the sweet and sour and always for the imaginative. The abundance of herbs in the garden, the many exotic spices introduced by medieval traders and the influence of the Sorb and Bohemian cuisine have added plenty of extra flavour to local dishes from the simple stew to the hunter's game, from cherry crumble cake to sweet dumplings with bilberries. The standard grey broiler has been banished from the table; the free state is now fully focussed on its culinary heritage. This is partly down to Ingrid Biedenkopf, the wife of the former leader of the state, who at the beginning of the 1990s called on hobby cooks and housewives to send in their favourite recipes. The result is a useful and practical work of reference – entitled "Sächsische Küche" – no self-respecting Saxon kitchen should be without.

"LEIPZIGER ALLERLEI"

Whether you believe the old saying that here beautiful girls grow on trees or not, to the joy of the creative cook Saxony does cultivate an entire range of edible delights in its fields and gardens, on its trees and bushes and in its forests and rivers. "Leipzig variety" or "Leipziger Allerlei" is thus an appropriate name for one very popular local dish. Carrots, peas, kohlrabi, cauliflower and asparagus are lightly steamed in lovage and nutmeg, morel mushrooms fried in butter, crayfish boiled and bread dumplings steamed. The vegetables and crayfish tails are covered in a creamy herb sauce, dribbled with melted butter and garnished with the morels. In the olden days, when mill streams used to run right through the heart of Leipzig, the cooks of the house hitched up their skirts, stepped into the water armed with buckets and plucked the crayfish out

from under the roots of the trees lining the banks. Today there's no need to get your feet wet; pre-packaged scampi is the perfect substitute.

"STOLLEN" FROM DRESDEN

The traditional "Stollen" from Dresden has also undergone a few changes. Hundreds

of years ago it was a lean sweet bread eaten during periods of fasting, totally devoid of butter. Over the years ever more ingredients were added, turning the humble "Stollen" into a masterpiece of Saxon cuisine, the success of the cake directly proportional to the experience and expertise demonstrated in its preparation. Brought gently steaming out of the oven, its crust golden brown, memories of the good old days loom large: "D'you remember when Grandfather was a little lad? That time he marched through the snow to the baker's with his handcart to pick up the village's Stollen and the baking trays all slid off the cart …"

lemon and sultanas which is topped with a mixture of sugar, butter, eggs and custard and sprinkled with cocoa and sugar.

Bottom right: *Potato soup in Saxony contains not just the humble potato but also carrots, onions, celeriac, leek, bacon and meat.*

Right:

The Sächsische Schweiz (Saxon Switzerland) owes its name to two Swiss painters living in Dresden during the 18th century who, plagued by home- sickness for their native country, found some solace in its rolling hills and craggy peaks. Although nowhere near as high as the Alps, the area is one of great beauty and extremely popular with hikers.

Far right:

"If it's a holiday at the seaside you're looking for, then you're about 100 million years too late", is the witty slogan plastered all over the Sächsische Schweiz's holiday brochures. The bizarre rock formations of the Elbsandstein- gebirge are, however, a fair exchange for what was once an ocean during the Cretaceous Period.

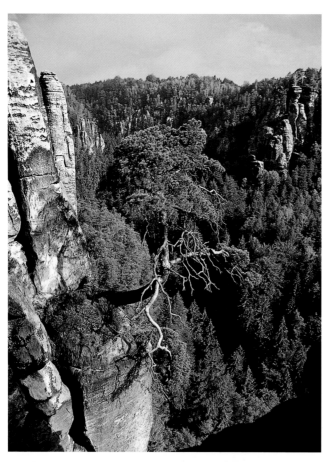
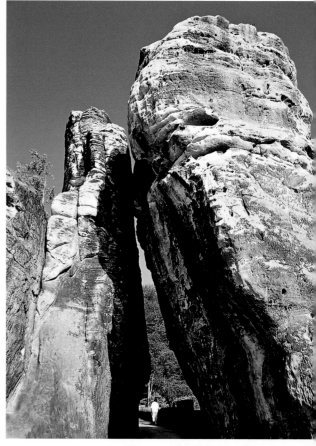

Right:

According to the libretto, Carl Maria von Weber's "Freischütz", the model German Romantic opera, takes place in the Bohemian Forest. The work was written follow- ing Weber's spate as director of the opera house in Dresden. Who knows: maybe it was the dramatic scenery of the Bastei and not Bohemia which provided him with the inspira- tional backdrop for his bullet scene in the Wolfsschlucht gorge!

Right page:

During the 19th century the event of paddle steam and the railway made the Elbsandsteingebirge accessible to both Saxons and Bohemians.

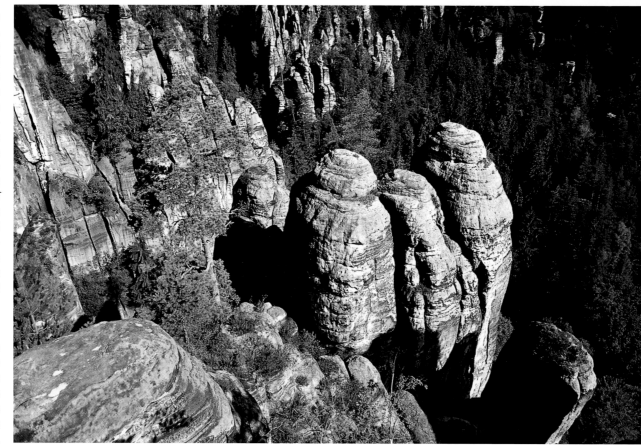

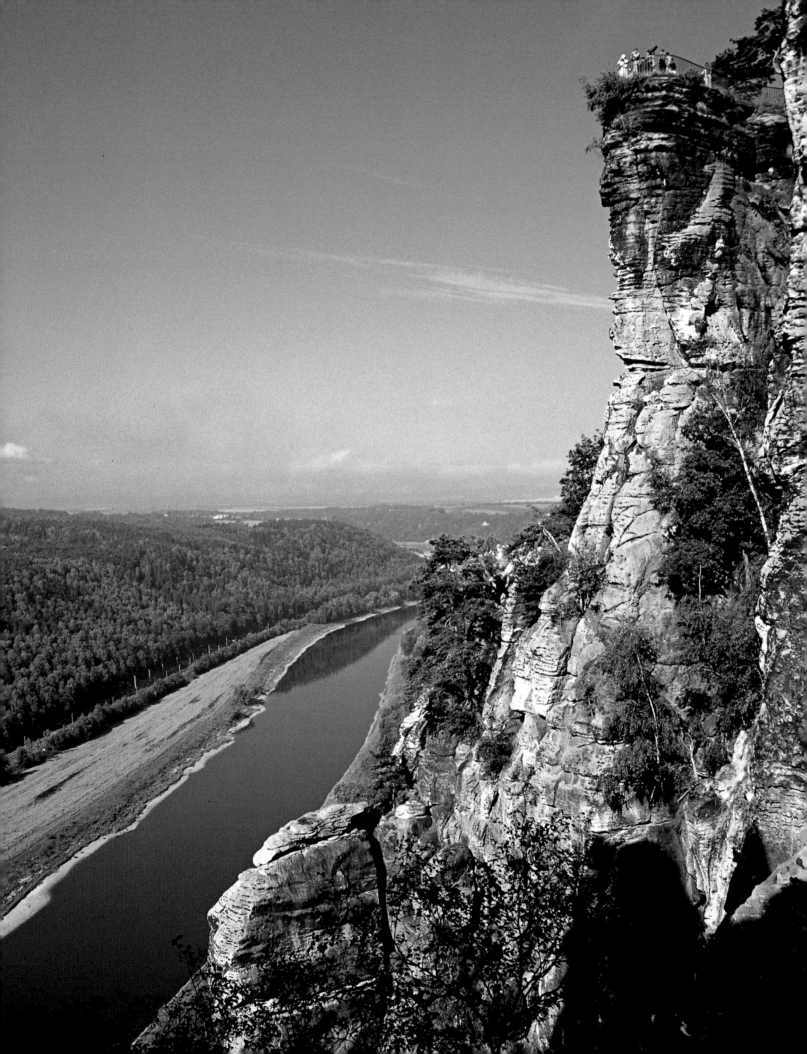

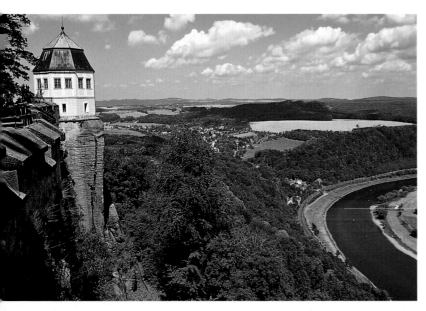

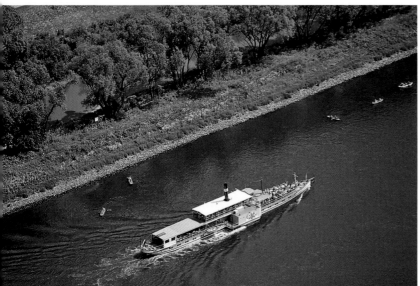

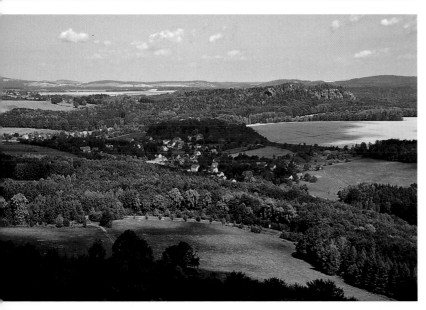

Top left:
*Festung Königstein.
During times of unrest
the potentates of Saxony
sought refuge within its
mighty walls, taking*
*their state coffers and
art treasures with them
and leaving their under-
lings to suffer at the
hands of their aggressors.*

Centre left:
*The historic fleet of pad-
dle steamers which has
navigated the waters of
the Elbe since 1837 is
a source of local pride.*

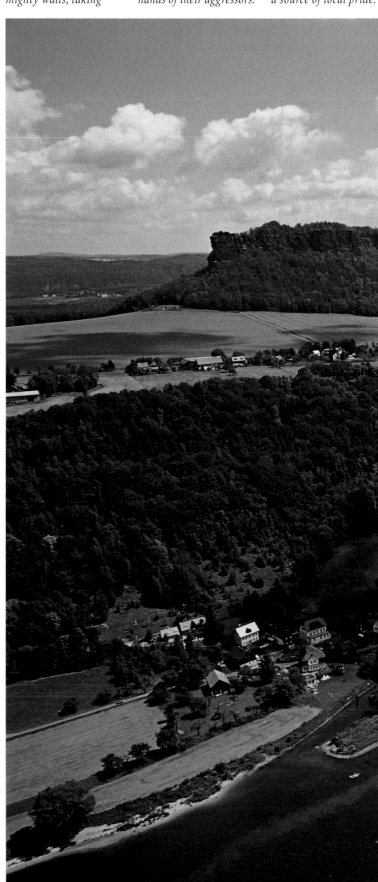

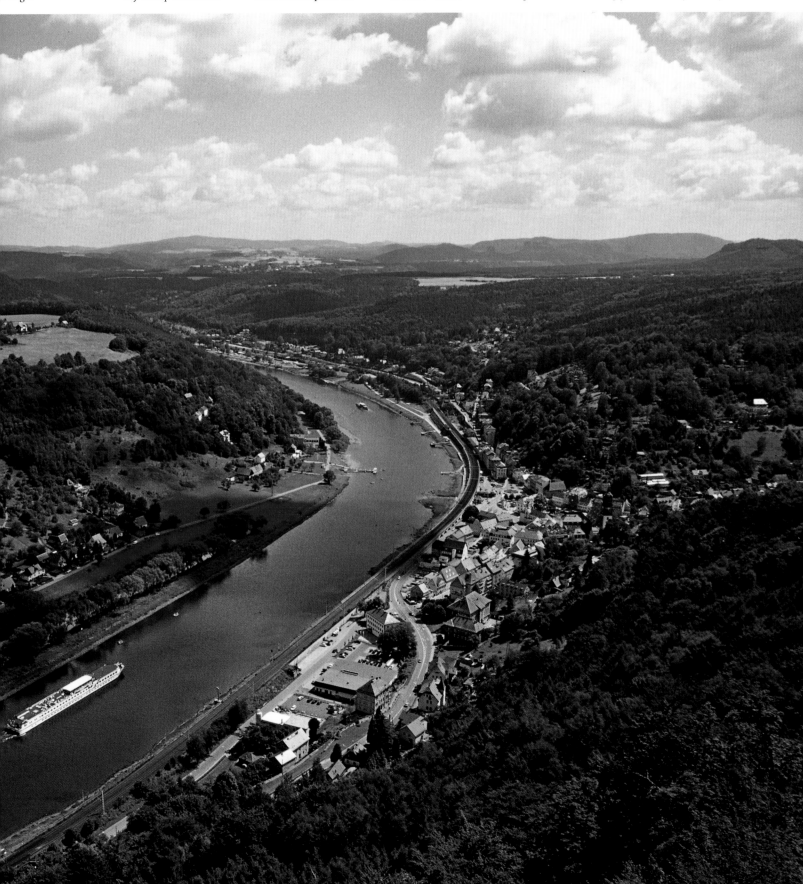

...he boats with their original, carefully preserved steam engines ...e protected as part of ...xony's industrial ...eritage.

Bottom left:
For centuries the fortress at Königstein was thought to be impenetrable until in 1848 apprentice chimney sweep Sebastian

Abratzky boldly managed to scale the walls. It was Saxony's state prison from 1591 to 1922, detaining various troublesome contemporaries

such as Russian revolutionary Mikhail Bakunin, Social Democrat August Bebel, writer Frank Wedekind and satirist Thomas Theodor Heine.

Below:
It wasn't only in times of crisis that the Saxon court sallied forth to Königstein. Its glorious panorama provided a spectacular backdrop for

all kinds of royal festivities. With buildings dating from the late Gothic to the 19th century, the enormous fortress is now an open-air museum of military history.

Right:
Bautzen or Budysin at the heart of Upper Lusatia is the political, cultural and spiritual hub of the Sorb homelands. The city was founded in 1002, the year in which the castle built by the Slavic Milcani was first recorded.

Far right:
Görlitz evolved ca. 930 years ago at the intersection of two major trade routes. With over 3,600 buildings from the Gothic, Renaissance, baroque and "Gründer-zeit" periods, the city on the Neisse reads like a history of urban architecture. Patrician houses belonging to the city's clothmakers line the Untermarkt with its famous weighhouse.

Right:
At the end of the Second World War the River Neisse or Nysa formed the border with Poland, with Görlitz, once the proud "gateway to Silesia", becoming Germany's easternmost outpost. The areas on the opposite bank of the river became the Polish town of Zgorzelec, mainly inhabited by Poles who had been driven from their homes in what is now the Ukraine. In 1998 Görlitz and Zgorzelec pro-claimed themselves a binational City of Europe which is striving to become the cultural cap-ital of Europe in 2010.

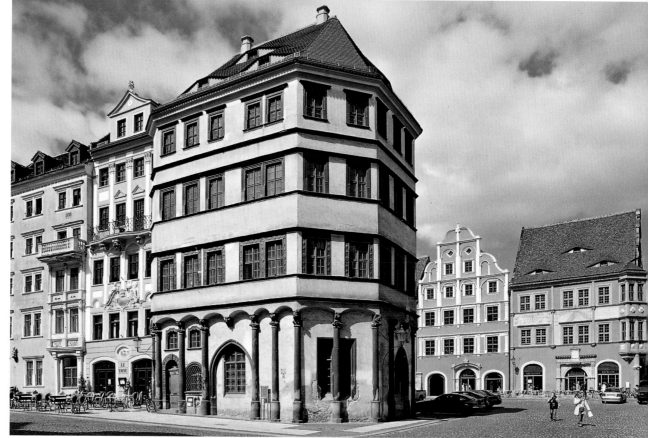

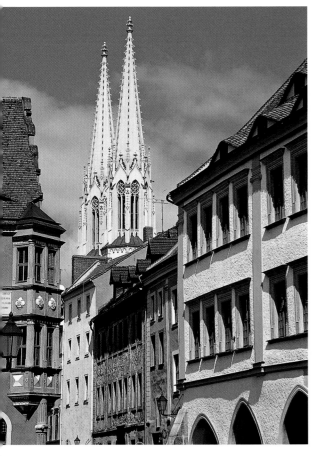

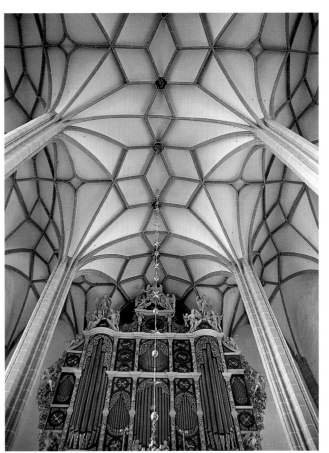

Far left:
The parish church of St Peter and St Paul in Görlitz with its neo-Gothic towers was built during the 15th century to replace a late Romanesque basilica.

Left:
The original interior of the five-aisle hall church of St Peter and St Paul was destroyed by fire at the end of the 17th century and subsequently baroqueified. Major artefacts dating back to this period are the altar and pulpit, three Protestant confessionals and an organ by Eugenio Casparini from 1703.

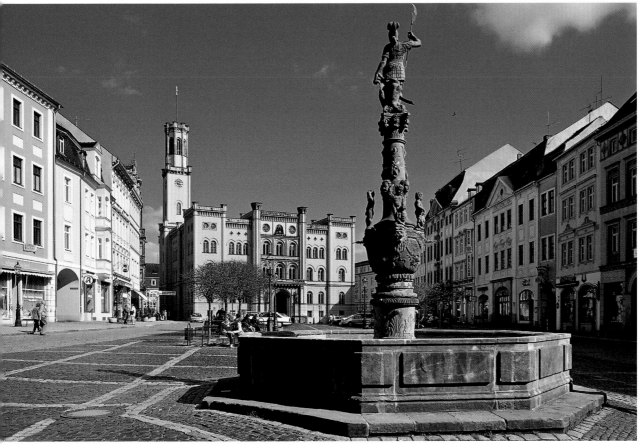

Left:
From April 30 to May 2, 2004, the people living in the corner of Europe straddling Germany, Poland and the Czech Republic along the River Neisse threw a huge party to celebrate the expansion of the European Union. The market place in Zittau was absolutely packed, with people dancing joyously around its historic fountain and outside the doors of its neo-Renaissance town hall.

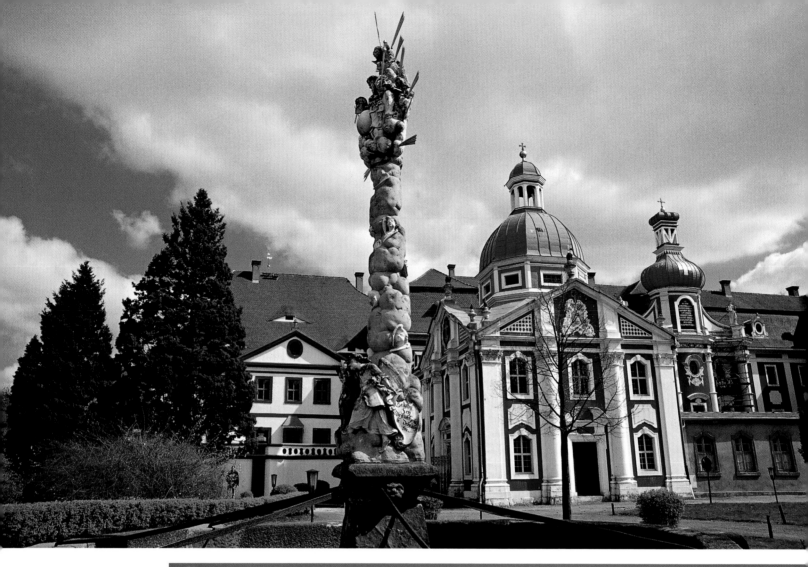

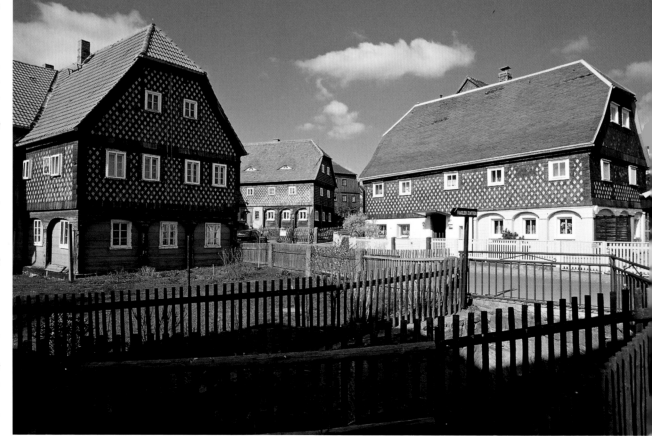

Above:
Kloster Marienthal on the edge of the Zittau Mountains has been home to the sisters of the Cistercian order since 1234. In 1992 the nuns founded an international centre with the aim of reconciling and encouraging dialogue between the people living in the River Neisse area, regardless of their nationality or religious beliefs.

Right:
The traditional houses of eastern Saxony, such as these in Obercunnersdorf, are built of timber. The living area on the ground floor is framed by an arch construction which bears the load of the upper storey and once absorbed the vibrations from the looms in the cottage spinning room.

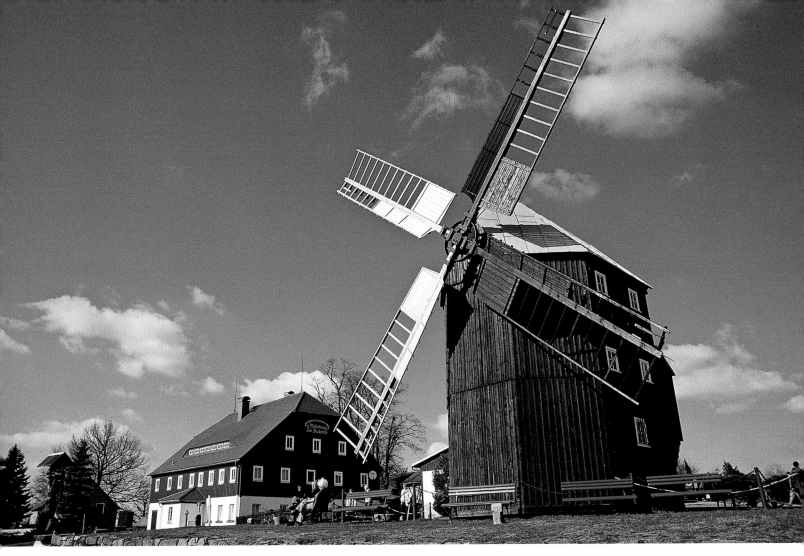

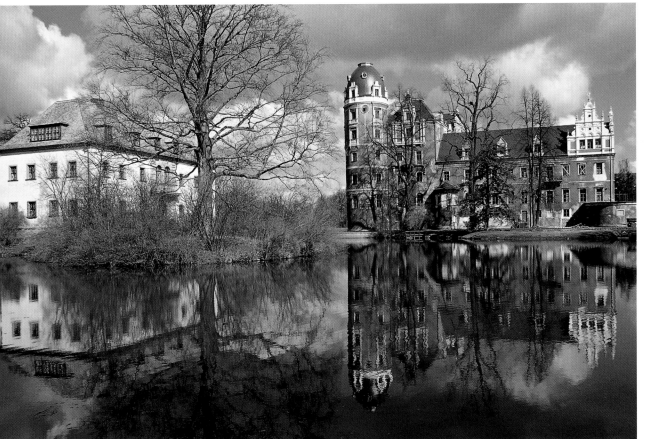

Above:
There were once 25 windmills in Kottmarsdorf; this one is the sole survivor. Once you've marvelled at the view from the top of the Pfarrberg there's bread and cake to be savoured in the museum bakery, fresh from its wood-fired oven.

Left:
On July 2, 2004, the UNESCO board took a unanimous decision to make the Muskauer Park straddling the River Neisse a World Heritage Site. Landscaped by Count Pückler-Muskau in the early 19th century, the application was jointly made by Germany and Poland.

Scenes from folk tale "Dr Johan Faustus" adorning the walls of Auerbachs Keller fascinated young student Goethe, prompting him to set two of his scenes from "Faust" here. A wooden statue hanging from the ceiling of the tavern depicts Faust's barrel ride.

The first long-distance train in Germany puffed its way from Leipzig to Dresden in 1839. Leipzig soon had no less than four stations, one for each point of the compass. To make things easier for all concerned, a central station was planned. In 1915 the monumental edifice was ready for operation, with 26 platforms the biggest terminus on the Continent. It was absolutely unique; as the building was jointly run by Saxony and Prussia there were two sets of everything, from the administration to the entrance halls, from the luggage office to the waiting rooms, with thirteen platforms for each partner. Every morning at nine on the dot, halfway between platforms 13 and 14, the Saxon and Prussian directors shook hands and synchronised their watches, a ritual which continued until the station came under Nazi rule. Risen from the ashes of the Second World War, restored and rebuilt, Leipzig's station is today a busy shopping centre straddling several floors. The trains are almost a secondary concern, gliding in and out of the terminus as noiselessly as possible.

Now as in the past, visitors arriving at Leipzig's main station are drawn to the city by its cosmopolitan hospitality, the beauty of its historic buildings and a humming arts scene. Over 30,000 students attend the second-oldest university in Germany, founded by the burghers of Leipzig as the Alma Mater Lipsiensis. The Choir of St Thomas's and the Gewandhausorchester carry on Leipzig's tradition of music across the globe, with publishing houses and media outlets of renown upholding its position as a major communications venue. High-tech concerns are proud of the label "Made in Leipzig" and the trade fair and exhibition centre, one of the most modern in Europe, is rapidly turning the city into a pivot for trade between east and west. Leipzig and the surrounding countryside also offer plenty of scope for relaxation. Parks and canals diffuse the hard lines of the urban centre, river meadows and forest soften its edges and the lunar landscape of the old mining areas has been flooded, creating a giant lido with beaches of the finest sand. Naming Leipzig as the venue of the next World Cup in 2006 was a good choice. After all, this is where the Deutscher Fußballbund (German Football Association) was founded in 1900...

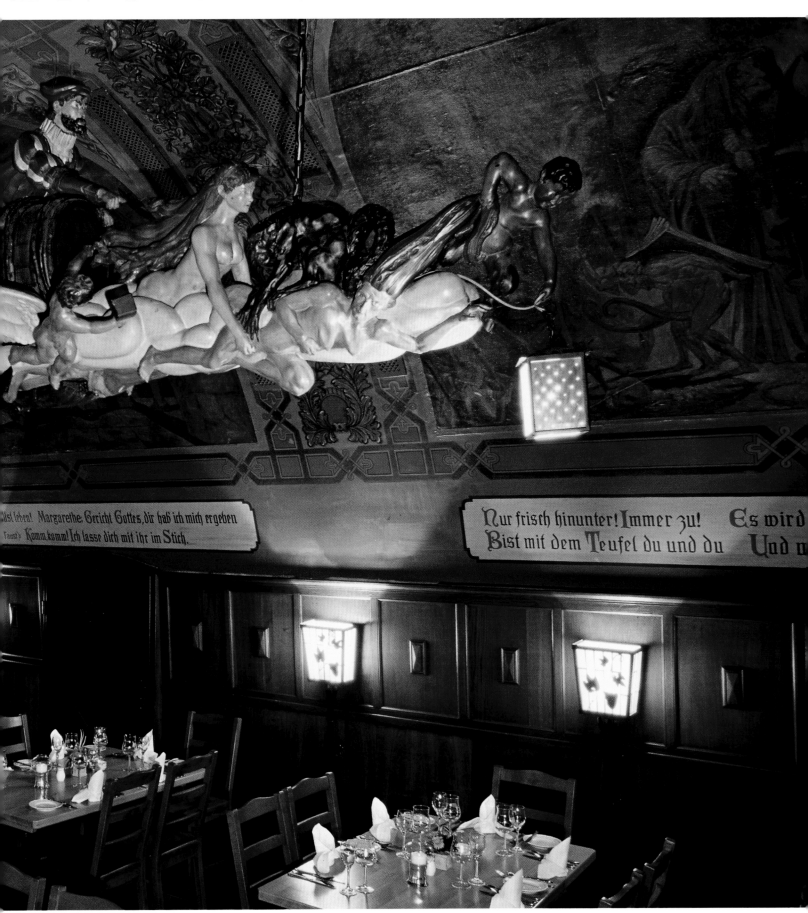

Fancy boutiques snuggle under the arcades of the old town hall in Leipzig, their bright window displays enticing shoppers to come in and buy. The market square wasn't always as serene and peaceful, however; it was once a place of execution, the last man to lose his head here being Johann Christian Woyzeck for stabbing his lover to death in 1824.

Right page:
Nuremberg merchant Hieronymus Lotter settled in Leipzig in the 1520s. He married the daughter of a local councillor and acted as mayor to the city from 1555 to 1573. One year after taking office he had a magnificent new administrative building erected in just nine months, creating what is now one of the oldest and most beautiful Renaissance town halls in Germany.

Venerable representatives of the state closely observe the goings-on in the great hall of Leipzig's Altes Rathaus or old town hall. The building now houses a museum of local history, tracing the city's past back to its beginnings as a Slavonic settlement on the River Pleiße.

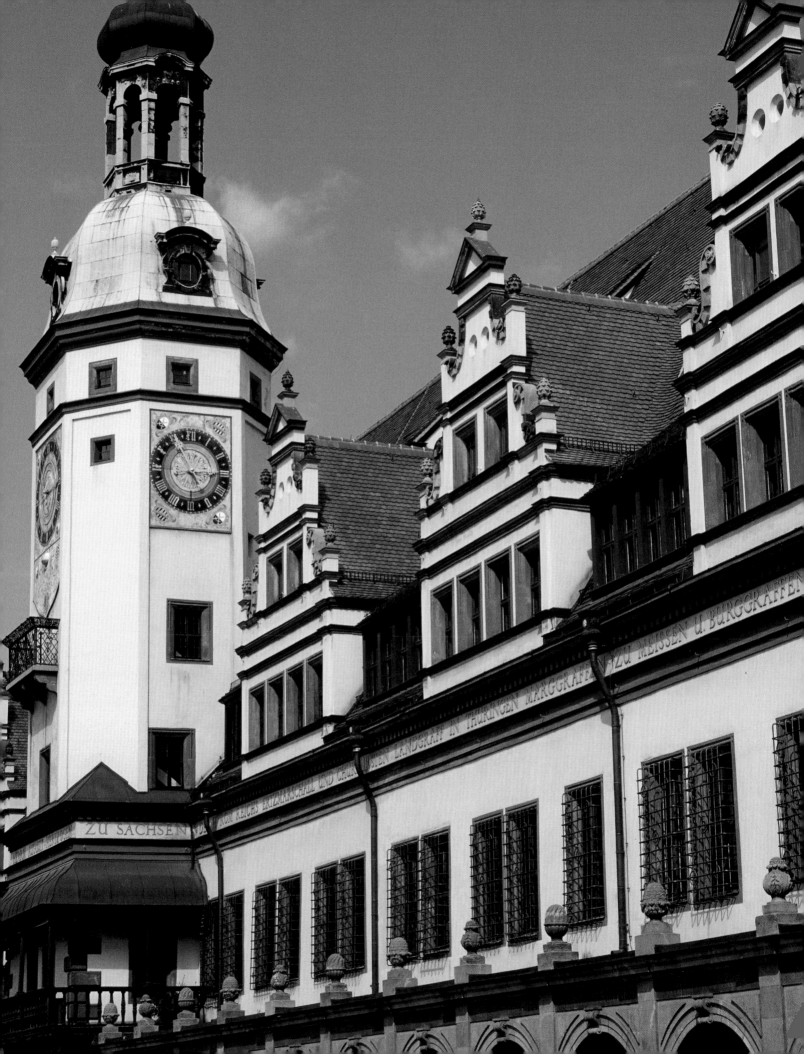

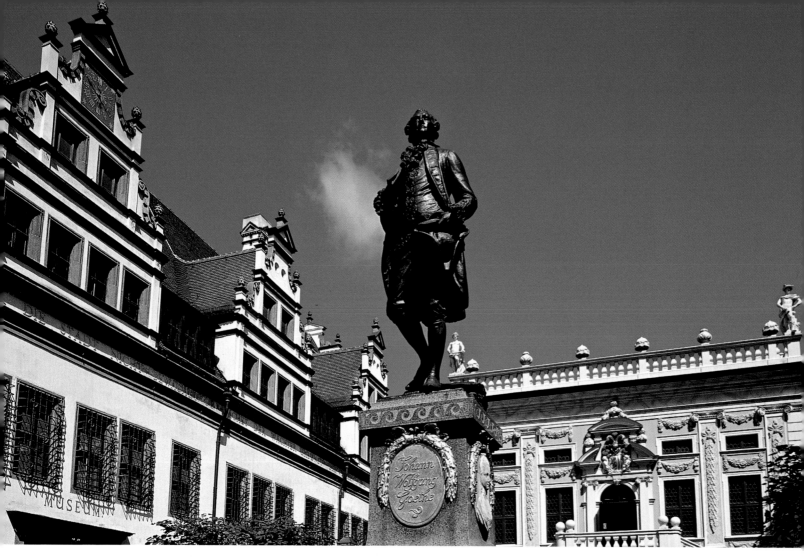

Above:
The Altes Rathaus and old stock exchange line two sides of the Nasch-markt with its statue of the young Goethe. The splendid facade of the exchange proudly bears Leipzig's coat of arms.

Right:
Turned down by the university because he was too young, a dis-appointed Gottfried Wilhelm Leibniz (1646–1716) abandoned his native city of Leipzig.

Far right:
Schiller lived with his friend Christian Gottfried Körner in Dresden and Leipzig from April 1785 to July 1787, returning to Leipzig in 1789 for his engagement to Charlotte von Lengefeld.

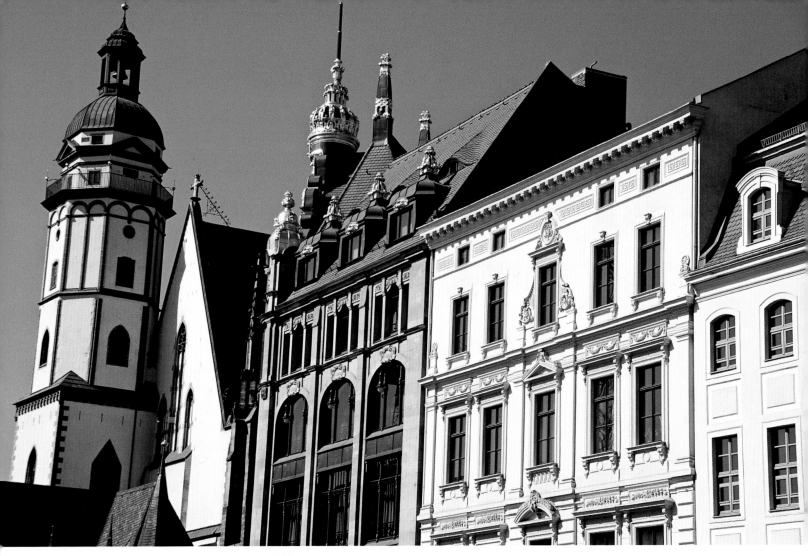

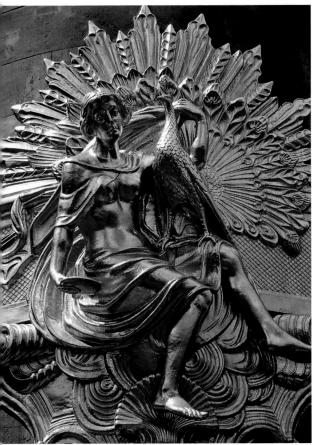

Above:
The late Gothic Thomas-kirche (St Thomas's) with its baroque steeple was where Johann Sebastian Bach was organist and cantor for 27 years.

Left and far left:
Fashion house Topas was built opposite the Thomaskirche in 1908 in an orgy of Jugendstil and neo-baroque. It has recently been expertly restored and is now occupied by a bank who appropriately do business under an ostentatious crown of gold.

Right:
Leipzig's Nikolaikirche with its domed baroque steeple was originally a Romanesque church dedicated to St Nicholas, the patron saint of merchants. In 1982 locals began holding their Monday prayers for peace here; in 1989 the now famous Monday demonstrations through the heart of Leipzig started out from the Nikolaikirche. On October 9 70,000 people peacefully marched for peace and freedom, the state thankfully laying down its weapons instead of aiming them at the demonstrators.

Right page:
The interior of the Nikolaikirche was refurbished in the neo-classical genre at the end of the 18th century on the initiative of mayor and head of the parish council Carl Wilhelm Müller. Ten white grooved pillars ending in ornate fronds of palm bear the Gothic vaulting hidden beneath the coffered ceiling. This is where Bach's "Passion According to St John" was first performed. On October 9, 1999, a copy of one of the pillars was erected outside the church to commemorate the success of Leipzig's peaceful and effective revolution.

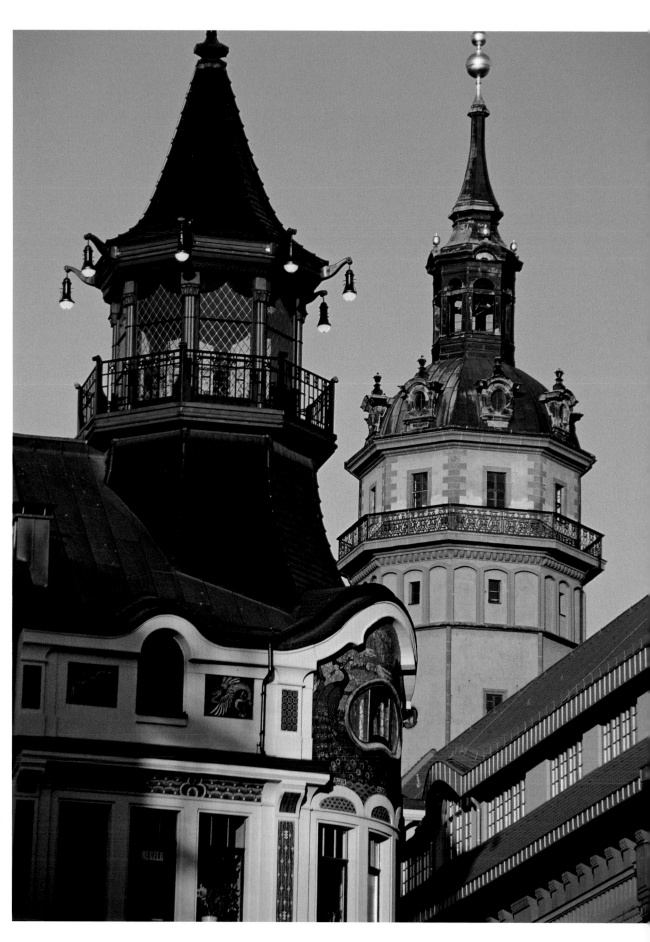

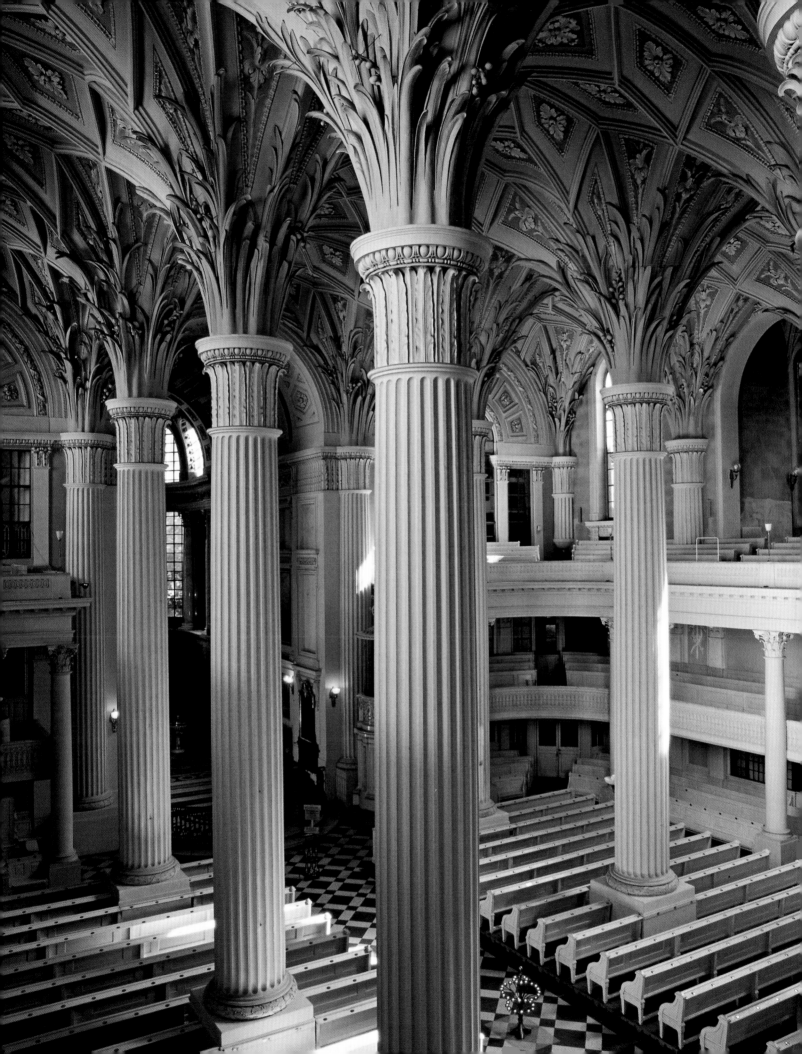

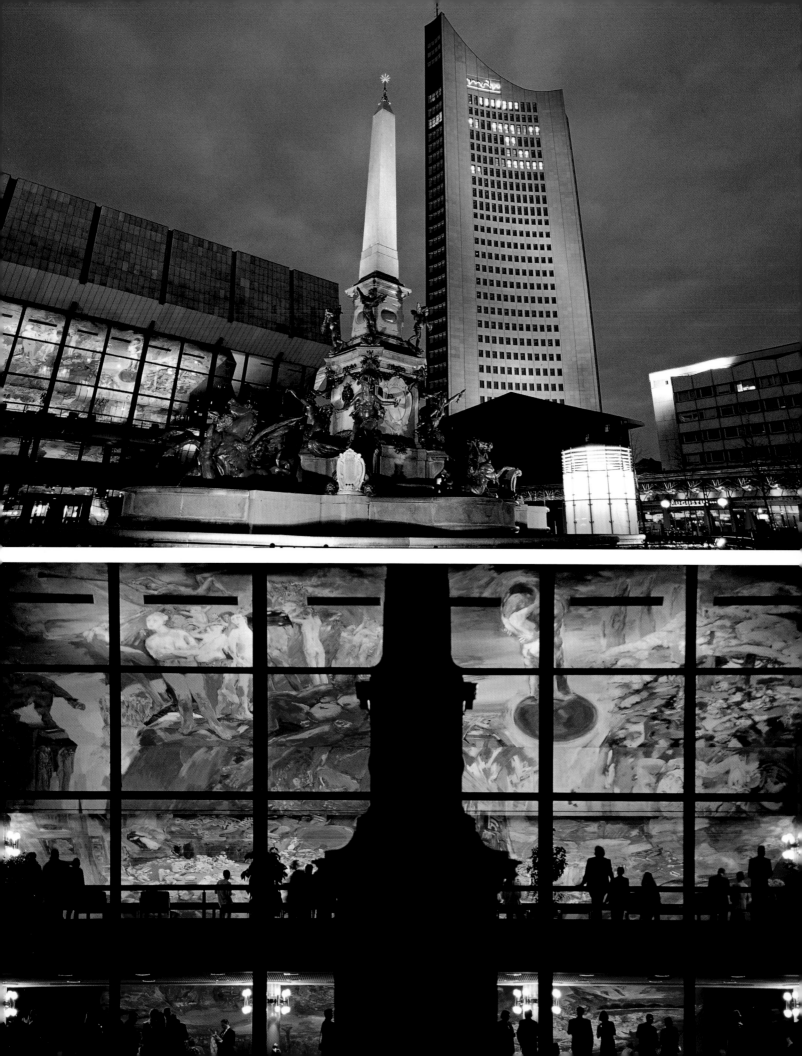

e neo-baroque foun-
in donated to Leipzig
merchant's widow
uline Mende with its
elisk of red Meißen
anite is the only build-
g on Augustusplatz to
ve survived the

ravages of the Second
World War. After a few
decades as Karl-Marx-
Platz the square is now
once more a busy focal
point, fronted on one side
by the glass facade of
the Neues Gewandhaus.

Below left:
The Thomanerchor
(Choir of St Thomas's) is
over 780 years old. The
young boys who sing in
it have a heavy workload,
with school, rehearsals,
voice training and

lessons on musical
instruments all part of
the daily routine. They
perform in the church
three times a week,
singing motets and the
Sunday service.

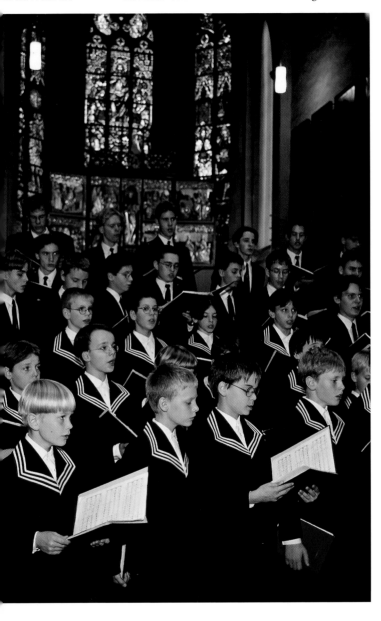

e Neues Gewandhaus
Augustusplatz with
excellent acoustics
d top-class symphony
chestra ardently car-
es on Leipzig's grand

musical tradition which
Gewandhaus directors
of renown, among them
Felix Mendelssohn
Bartholdy, Bruno Walter
and Kurt Masur, have

constantly pumped new
impetus into. The
Gewandhaus itself was
once a trade hall for
the city's cloth and wool
merchants.

Above:
The Reformation came
to St Thomas's with
Martin Luther's famous
Whitsun sermon in 1539.
The Romanesque church,
built in the 13th century
for Augustinian canons,

was turned into an aisled
hall church during the
14th and 15th centuries.
The sarcophagus con-
taining Bach's bones was
laid to rest here in the
choir and marked by a
bronze plaque in 1950.

Below:
Carl Seffner's statue of Bach shows him full of energy and vigour, with a scroll of manuscript in his right hand and his left held behind his back, itching to play the organ. Seffner also sculpted a likeness of the young Goethe for the city of Leipzig.

Below:
Opposite the Thomaskirche in Leipzig was once the school of St Thomas's where the Bach family lodged and the choirboys were given lessons. During Bach's day the choir numbered 55; today there are 90 young singers.

Right page:
SDG, "Soli Deo Gloria" (glory to God alone), were the letters with which Bach signed a great number of his scores. He took Holy Communion in [church of St Thomas's [the last time on July 2 1750. He died peace[...] at the age of 66 a f[...] days later on July 2[...]

80

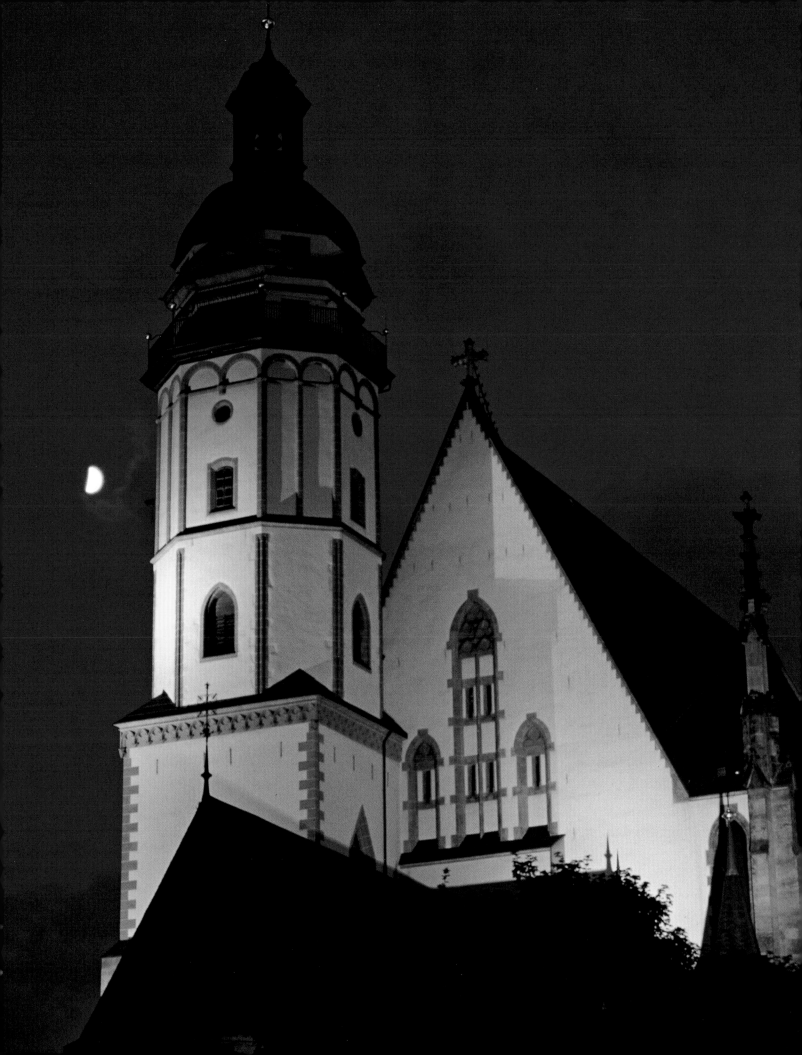

The Luther monument outside the church dedicated to St Anne in the old silver mining town of Annaberg-Buchholz. The Reformer was the son of a miner from Eisleben.

"Here I stand. I can do no other," professor of theology Martin Luther is quoted as having said at the Diet of Worms in 1521, refusing to retract his "Ninety-five Theses". He was then outlawed in the name of the emperor – as free as a bird, but in imminent danger of being burned at the stake as a heretic. To spare him a terrible end Elector Frederick the Wise had him "kidnapped" on his return journey to Wittenberg and brought to the Wartburg. Safely ensconced in the castle Luther then proceeded to translate the New Testament within the space of a few months. His powerful and vivid language, a mixture of the vernacular and official Saxon, laid the foundations for a unified, standard German which his contemporaries, who spoke a babble of dialects and struggled to write in Latin – if at all – had to date lacked.

At the foot of the very same castle in the town of Eisenach, in 1685 a musical genius was born whose magnificent music was to transcend both national and religious boundaries. For 27 years Johann Sebastian Bach was the appointed master of music in Leipzig and the cantor of St Thomas's. He wrote hundreds of works both sacred and secular, one of which was the famous "Coffee Cantata", a farce on the passion of the ladies of the time for the fashionable new beverage. Appropriately, he first conducted it at Zimmermanns Kaffeehaus in 1734.

At the very same time, a few streets further on Friederike Caroline Neuber was cleaning up the act at her theatre. Improvisation and juvenile farce were shown the door; Germany's first female theatre director was in the throes of reform. She demanded that her actors study their roles with care and stick to the script, keeping the plot coherent and enunciation clear in emulation of the classic French theatre. Neuber had to rule with a rod of iron in kid gloves, demonstrating diplomacy and cunning in her dealings with both her troupe, her aristocratic patrons and her scheming competitors. Her final discovery was a young parson's son from Kamenz, barely twenty, a student of theology and medicine in Leipzig who was mad about the theatre and whose first play, now long forgotten, she successfully staged. Gotthold Ephraim Lessing was later to become a classic in his own right with dramas such as "Minna von Barnhelm" and "Nathan der Weise". By this time Neuber had long died a pauper, destroyed by the horrors of the Seven Years' War, in a peasant's hovel in Dresden-Laubegast.

In Dresden-Neustadt, much later in 1899, a certain Erich Kästner was born, writer of children's literature whose "Emil und die Detektive" (Emil and the Detectives), "Das doppelte Lottchen" (The Double Lottie) and "Das fliegende Klassenzimmer" (The Flying Classroom) have made him famous the world over. Fine powers of observation and a riotous imagination, empathy with the reader and the ability to poke fun at human weaknesses and contemporary afflictions are the trademarks of Kästner's work. With their undertone of gentle scepticism towards anyone in a position of authority, his poems, which he modestly referred to as "everyday", novels and journalism are still highly relevant today.

There was another young author in Saxony whose powers of imagination proved even more powerful than Kästner's, almost powerful enough to knock down his prison walls. Stuck behind bars for repeated fraud, a ruined, desperately poor young teacher began writing stories full of warmth, despair and a strong belief in love, hope and the triumph of justice. A

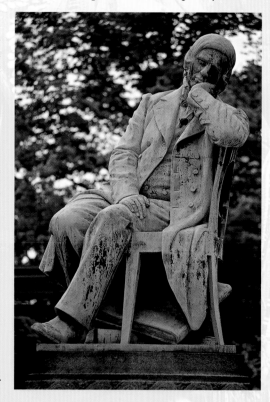

Left:
"To send light into the depths of the human soul". Robert Schumann's native Zwickau continues to honour the words of the great composer with its many high-calibre musical events.

Above:
Villa Bärenfett at the Karl May Museum in Radebeul near Dresden has a collection of American-Indian artefacts which is unique to Europe. Karl May himself had absolutely

FROM LUTHER TO THE SCHUMANNS

smart publisher in Dresden saw them and serialised them in his newspaper. Karl May's career took off. Released from detention the master of mystery and suspense abandoned the inhospitable world of reality for the realms of fantasy, charming generations of young readers with brave and bold heroes such as Winnetou and Old Shatterhand, Kara Ben Nemsi and Hadschi Halef Omar. The fact that May had never been to the Wild West or the wastes of Kurdistan was irrelevant; his tales were a work of fiction right down to the last letter. And splendid they are too.

A young musician from Zwickau demonstrated a greater sense of decorum when asking for his piano teacher's daughter's hand in marriage. Despite his valiant efforts Wieck refused to give up his child prodigy Clara who had been heralded as a great pianist at the tender age of nine, wanting something better for her than marriage to Robert Schumann. There was no disputing that the young man had tal-

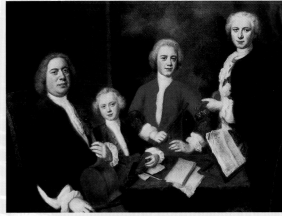

Top right:
The study at Villa Shatterhand. Despite his attempt to climb the social ladder, Karl May never quite managed to escape from his past as a small-time criminal and fraudster.

Bottom right:
Johann Sebastian Bach and three of his sons in a painting from 1730. Bach was proud of his family's musical talents

o first-hand knowledge *hatsoever of the life of any of his protagonists; is tales of the Wild West re pure figments of the nagination.*

and able to drum up a chamber group of instrumentalists and singers from the ranks of his own kith and kin.

ent, but to leave his daughter to rot as housewife and mother was definitely not what Wieck wanted. Clara Wieck and Robert Schumann married without his consent in 1840, the life and love of two children of the Romantic period an exercise in poignancy down to the last detail. Robert's "Scenes from Childhood" tell their story, played by Clara with a bitter sweetness.

Promising him the time of his life Mephistopheles enticed the gullible Faust into Auerbachs Keller where they were raucously received by a bunch of merry students full to brim with wine conjured up by Goethe's devil incarnate. A visit to the tavern today is far more civilised – even if you may encounter the odd likeness of the Prince of Darkness…

Right page:
Manufacturer of bags and suitcases Anton Mädler modelled the Mädlerpassage on the Galleria Vittorio Emanuele in Milan. Built between 1912 and 1914 as a showcase for his wares, the arcade has been lovingly restored, its glass-and-concrete roof protecting shoppers from the elements as they peruse the goods on sale today.

In 1525 university professor Heinrich Stromer from Auerbach in the Upper Palatinate had wine served to his students in the cellar of his town house in celebration of the Easter mass. Over the centuries his business boomed, with generation after generation of students – the young Goethe among them – taking liquid refreshment here after a hard day of lectures and seminars.

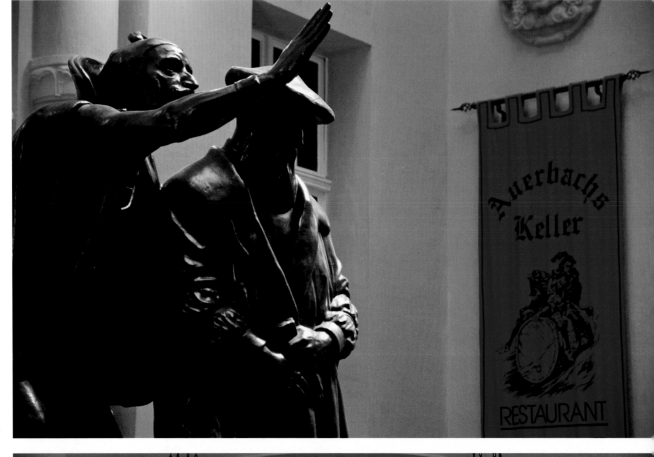

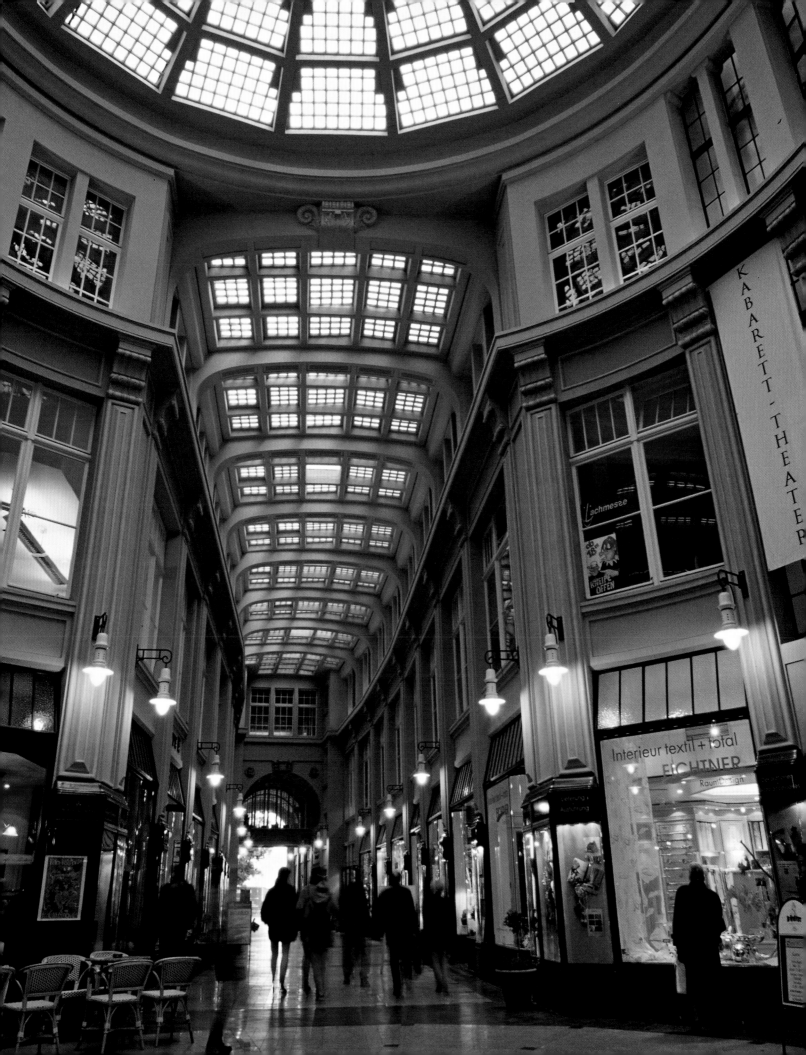

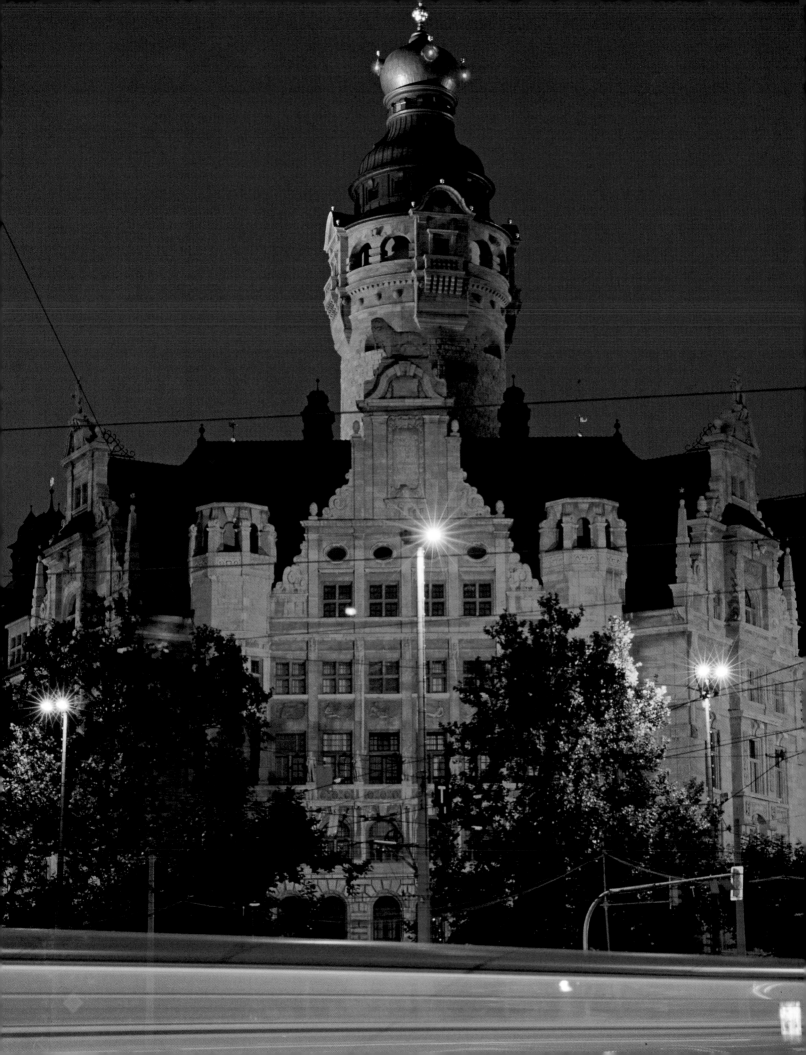

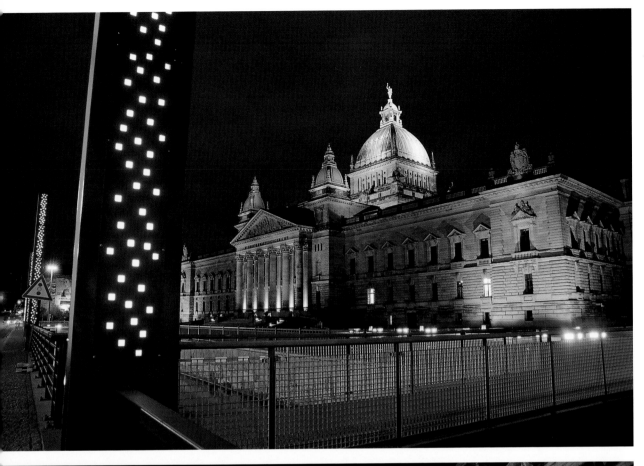

At the end of the 19th century the newly formed Deutsches Reich was deciding where to locate the highest court in the land, the Reichsgericht. With an eye to federalism and to keeping a healthy distance to Berlin Leipzig was chosen. Completed in 1895, it is now home to Germany's Supreme Administrative Court.

Left page:
In c.1900 Leipzig was a flourishing city of trade and industry with 500,000 inhabitants and many successful publishing businesses. Council architect Hugo Licht was commissioned to design a town hall to show off the prestigious status the city enjoyed. His plans incorporated elements of the mighty castle of Pleißenburg which was knocked down to make way for the vast new edifice, completed in 1905.

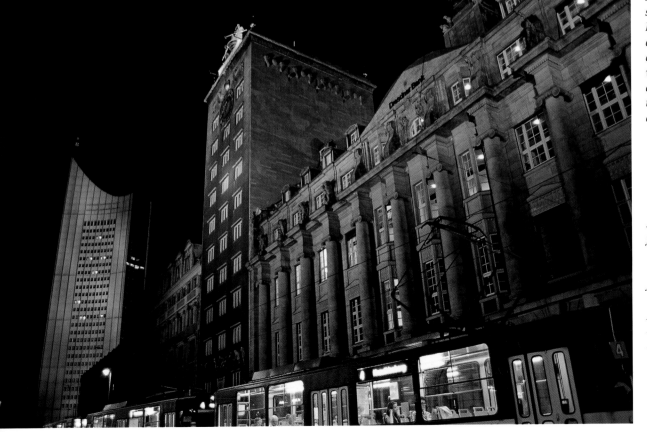

The Kroch skyscraper on Augustusplatz – Leipzig's first – was built in 1927/1928 by Munich architect German Bestelmeyer for the bank Kroch. Up until the 1930s Leipzig's Jewish population was second only to that in Berlin. With the rise of the Nazi regime Hans Kroch fled Germany; Kroch's wife died at the women's labour camp in Ravensbrück.

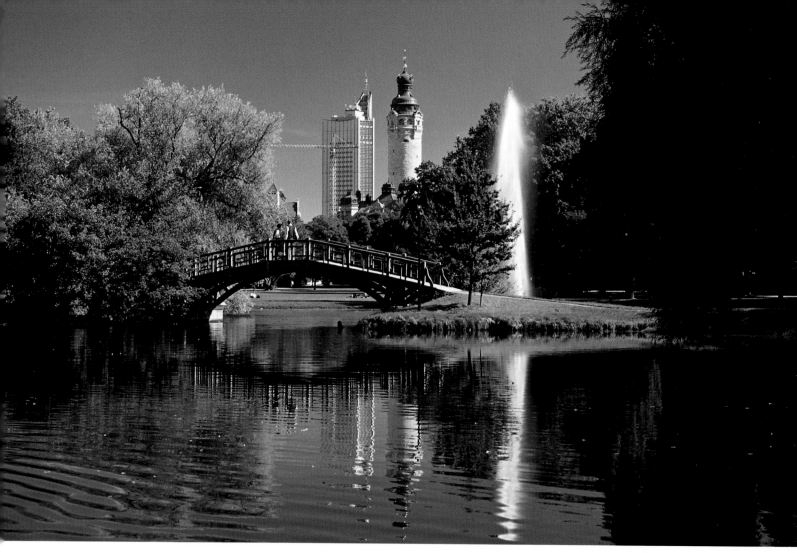

Above:
The Johannapark in Leipzig, landscaped in the style of an English country park by Peter Josef Lenné in 1858, is named after the daughter of banker Wilhelm Seyfferth who donated funds to have the park laid out.

Right:
The former city defences, torn down at the instigation of one of its mayors, now form a lush belt encircling the centre of Leipzig, providing its friendly populace with a place to relax, escape the hustle and bustle of the city – and listen to some first-class buskers.

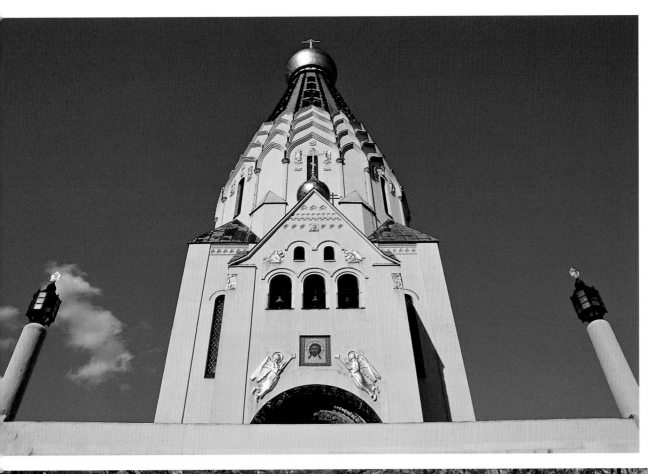

Left:
The Russian Orthodox Gedächtniskirche was built by Vladimir Alexandrovitch Pokrovski and consecrated on October 13, 1913, 100 years after the Battle of the Nations. Built with Russian donations the church is both a memorial to the 22,000 Russian soldiers who fell in the battle and a place of worship for the city's Russian community.

Below:
Not far from the city centre is the Clara Zetkin Park, named after the women's rights activist and politician from Saxony who studied in Leipzig and in 1878 joined Germany's Socialist party, the SPD, here. Part of this beautiful area of forest has been turned into an English landscaped garden.

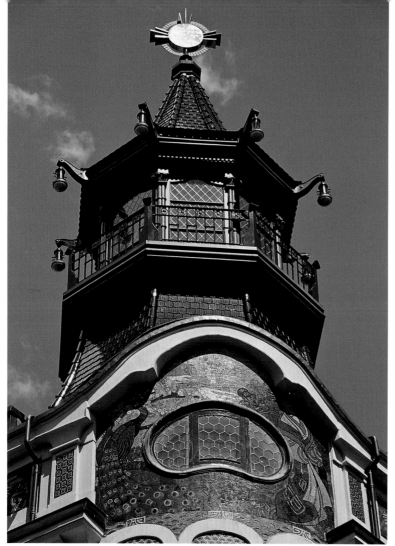

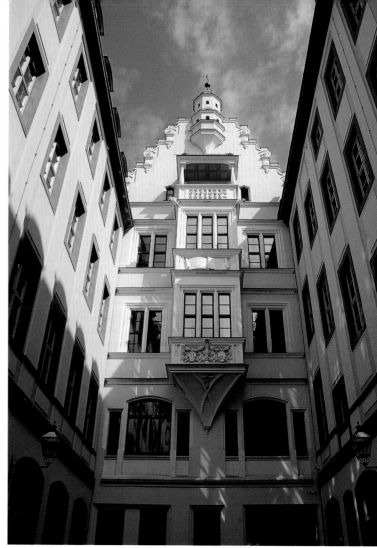

Above and right:
The Riquethaus is one of Leipzig's most impressive Jugendstil houses. The Riquets were French Huguenots who came to the city during the 18th century, when Georges Riquet began trading in coffee and home-made chocolate. Two copper elephant heads guard the main entrance.

Above right:
Barthels Hof is one of the old merchant stores where coaches could drive in on one side, inspect and purchase goods and then drive out on the other. The stores were on the ground floor, with the offices and private apartments above.

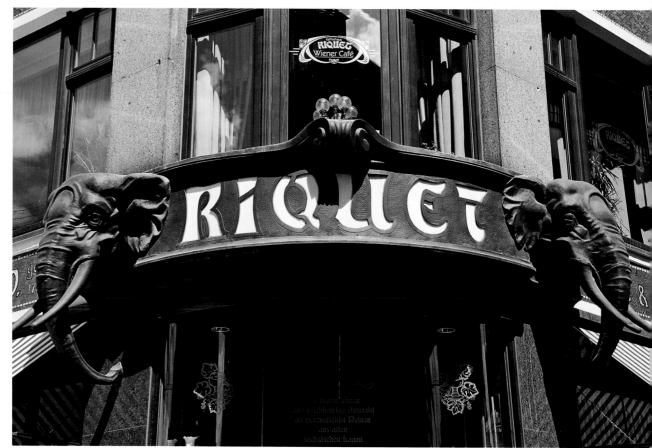

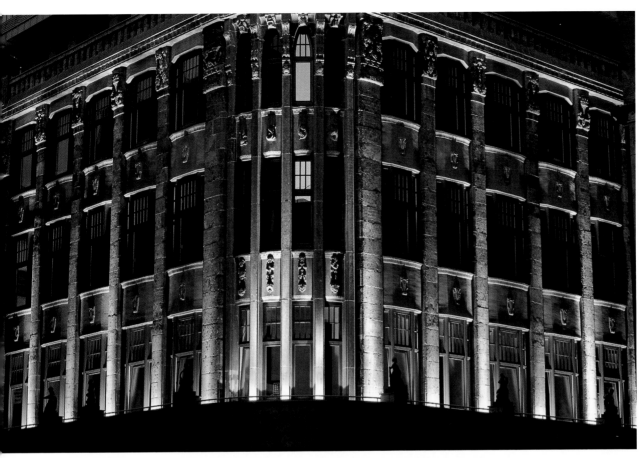

Left:
Building was begun on the mighty Specks Hof trade hall in 1908 and completed in 1928. The complex was named after the site's former owner. His famous ancestor Maximilian Speck von Sternburg (1776–1856) was a passionate collector and it's to him that the Städtische Museum der Bildenden Künste (City Museum of the Fine Arts) in Leipzig owes its stock of two hundred exquisite paintings by Cranach and Caspar David Friedrich, among others.

Below:
Barthels Hof, now restored, is a hot favourite with architecture enthusiasts and gourmets alike, with the restaurant serving excellent Saxon cuisine.

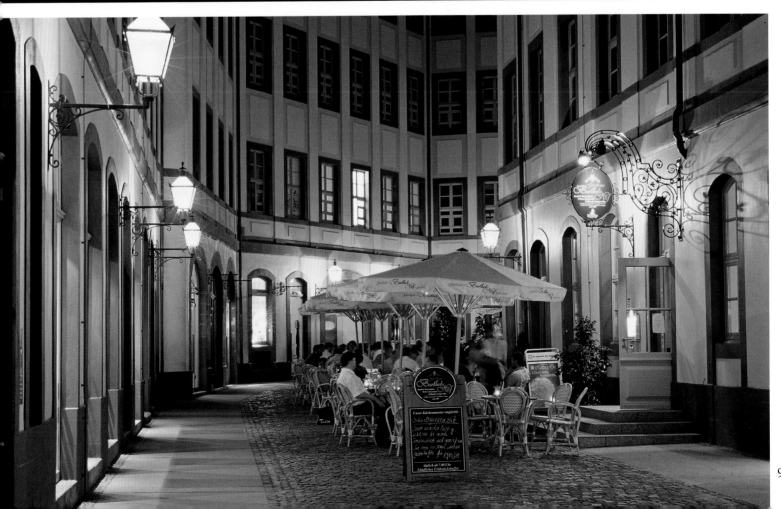

Three high courtyards covered with glass roofs shed light onto the goods on sale at Specks Hof. Leipzig commissioned three contemporary architects to refurbish the early 20th-century trade hall, incorporating original elements of its design; Bruno Griesel, Moritz Götze and Johannes Grützke each created a thematic ensemble for one of the three areas.

In 1996 a few enthusiastic jazz fans set to work turning an old Leipzig bookstore into a hip music venue, using anything they could lay their hands on. The name of the club comes from a ballroom in Kiel – the only sign they could find at the time. SPIZZ has since made a name for itself, providing a café looking out onto the Altes Rathaus by day and jazz in the cellar at night.

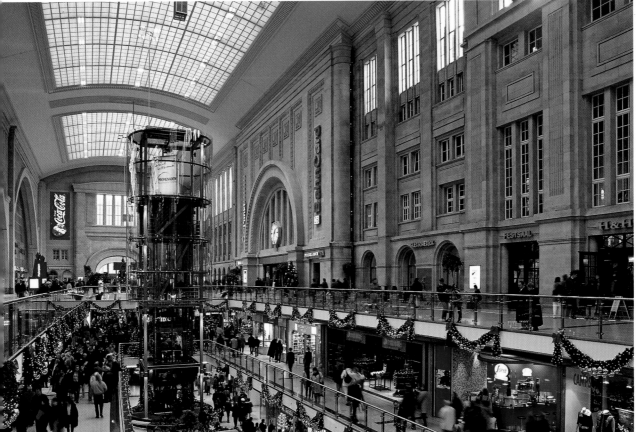

Above:
With the construction of a new complex in the north of the city, traditional centre of trade Leipzig has gained a new economic venue which will catapult it into the future. The enormous glass hall forms the impressive centrepiece of the huge exhibition and congress centre.

Left:
Leipzig's giant central station, now superbly restored, is a world in itself which is fascinating to explore. Its departures board reads like an advert for the expansion of the European Union, with trains leaving for Prague (Praha), Wroclaw (Breslau) and Paris – and many other now readily accessible European locations.

93

THE MAGIC OF THE SAXON

The dialect of Saxony isn't exactly revered in the German-speaking parts of Europe. The popular cliché that Saxon is the language of stony-faced bigots has done much to boost the ego of many a self-important West German accent, making Saxon a figure of fun amongst those blissfully unaware of humorous linguistic quirks such as "Bliemchen" ("Blümchen" or "little flower") for coffee which is so thin you can see the cup pattern through it. People also like to forget that many of Germany's philosophers, musicians and writers of renown had a definite Saxon twang to their voices. The great Leibniz, for example, left Leipzig at the age of twenty yet kept his native patois for the rest of his life. Both Johann Sebastian Bach and Richard Wagner were also most probably attuned to Saxon melodies of speech. As regards Lessing's witty and charming (Saxon) noblewoman Minna von Barnhelm, the main protagonist of his most famous comedy, it remains to be seen whether the officious Prussian Major Tellheim would have drawn his rapier with such aplomb if her words of love had been in Prussian or Bavarian. And if you're still not convinced, then consider this; the seventeen-year-old Goethe, born and bred in Frankfurt, was sent by his father to study in Leipzig to both profit from the worldliness of the big city and from the German spoken there, reckoned to be particularly refined and worthy of imitation.

THE FOUNDATIONS OF NEW HIGH GERMAN

During the 16th century one nuance of the Saxon dialect became a model for written German, laying the foundations of the New High German spoken today. In 1533 Martin Luther translated the Latin Bible into German, marking the first outstanding literary event in the history of the German language. His Bible made use of German officialese, as the only German texts at that time were drawn up in legal chambers and offices. As in the rest of Europe most other documents – whether scientific, philosophical or theological – were published in Latin. The language of Luther's Bible left its mark on generations of readers, resulting in the evolution of a standardised High German which was spoken throughout the land. Wittenberg itself, where Luther allegedly nailed his Ninety-five Theses to the door of the church, became one of Germany's first major centres of book production, with Hans Lufft printing over 100,000 Bibles here in the space of fifty years from 1534 onwards. Luther's many theological writings and the reactions these provoked made up around one third of all printed matter in German at the time.

Poet Caspar Stieler (1632–1707) from Thuringia described Dresden, Leipzig and Halle as bastions of language; "… in these splendid cities the High German language reigns and triumphs, they are the guideposts of High German." But then came the literature of the 18th century and with it new standards, with the linguistic focus shifted to other parts of the country. In 1826 Franz Grillparzer claimed to have heard "the squawking of frogs" and "the positive baa-baa of sheep" in Dresden. When during the 19th century the Prussians gained supremacy over Germany the dialect which had once helped define a common German language fell into disrepute, sinking even further behind the Iron Curtain drawn firmly across the map of Europe. For decades the local lingo was ridiculed during the Cold War, with the Saxon slogans bandied about by goatee-bearded head of state Walter Ulbrich, a native of Leipzig, providing the opposition with excellent linguistic ammunition. The procedure was always the same; if the East German in a West German film was to embody the general air of Socialist decay and oppression adherent in the GDR, he or she spoke Saxon; whether a rude waiter in Rostock or a grouchy policeman on the Fichtelberg, Saxon definitely had negative connotations for the West.

What many Westerners – German or otherwise – still don't realise, however, is that Saxon isn't always Saxon. To a stranger to these parts the idioms of Dresden, Leipzig or Chemnitz may sound the same. Yet as in Bavaria, where the Franconians will be at great pains to explain that although strictly speaking they are Bavarian, they speak Franconian – in three different variations to boot – a native of Leipzig may not necessarily be able to understand somebody from the Vogtland; and a Dresdner may have trouble trying to decipher the mumblings of a fellow Saxon from the Erzgebirge. The number of different permutations of this particular strain of German currently stands at around 20. All the more reason to make sure that this linguistic phenomenon survives for many generations to come!

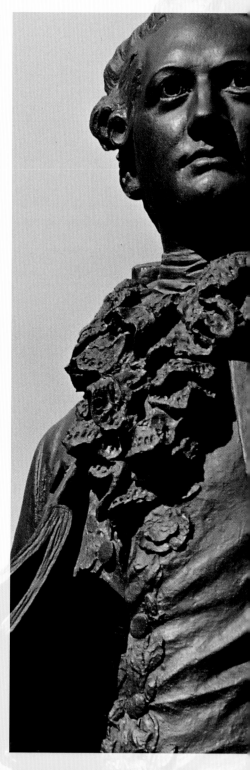

Above:
Gotthold Ephraim Lessing, a parson's son from the Saxon town of Kamenz, championed the ideals of the Enlightenment in his writings and dramas, calling for sense, tolerance, freedom and humanity as opposed to prejudice, despotism and the domination of the clerical and secular authorities.

Above:
Goethe spoke of Lessing's "Minna von Barnhelm" in glowing tones, praising the triumph of his female Saxon protagonists over the prim-and-proper values and sheer obstinacy of their Prussian rulers.

Top right:
If, when in Saxony, you fancy an open sandwich and want to try out your command of the local lingo, ask for a "Bemme".

Right:
Coffee which is so weak that you can see the floral pattern on the bottom of the cup through it has given rise to a poetic turn of phrase in Saxony: "Bliemchen-Kaffee".

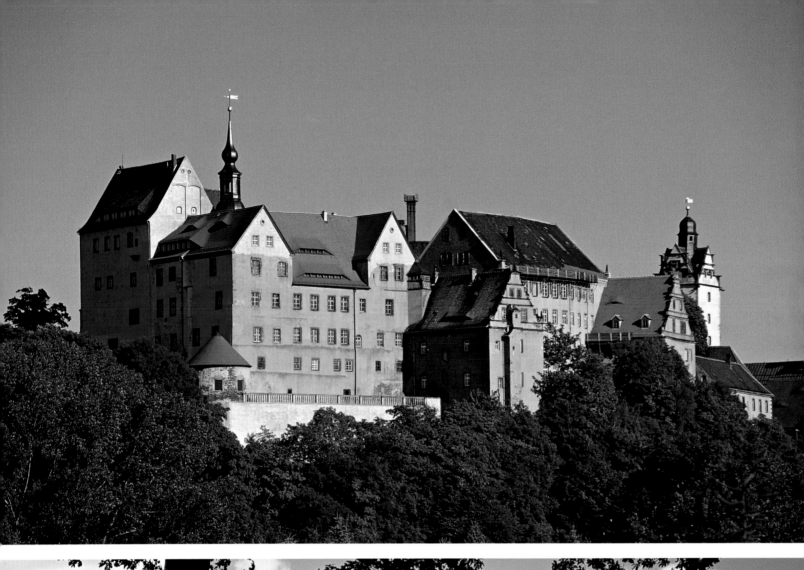

ft:

loss Colditz of escapist
e towers over the
n and valley of the
lde. Dating back to the
h century, the castle
s been put to many
es, including a brief
ll as a concentration
np for critics of the

Nazis in the mid-1930s.
Perhaps its greatest
claim to fame, however,
is as a high-security
POW camp for Allied
officers who were prone
to escape. Recently
restored, the castle now
has a museum devoted
to its former detainees.

Below left:
High up above the River
Mulde Schloss Rochlitz
watches over the town of
the same name. Its walls
of red porphyry have

many a tale to tell of
emperors, kings and
princes, its architectural
history spanning the ages
from the Romanesque to
the early Renaissance.

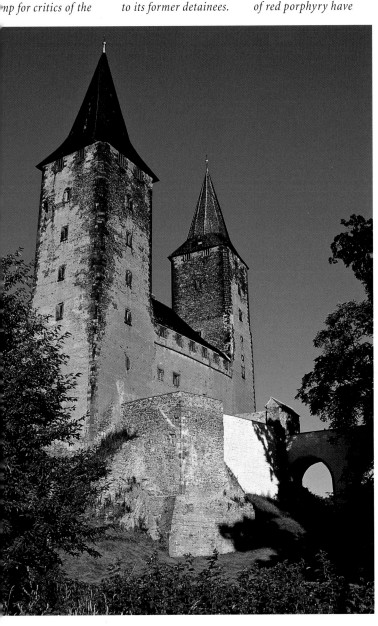

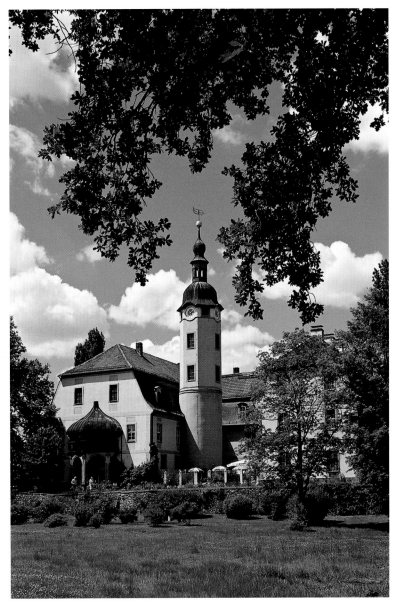

eft:

yllic Schloss Machern
ith its romantic land-
aped garden lies
tside the gates of
ipzig. It was fortified
 a moat until the con-

struction of the Leipzig-
to-Dresden railway
brought about a change
in the ground water
supply which caused the
moat to run dry.

Above:
The round staircase tower
in the courtyard and
the groin vault on the
ground floor are typical
of Schloss Machern's
original Renaissance

design. The baroque roof
with its lantern, onion
dome, orb, weather cock
and tiny gold star was
added to the palace in
the 18th century.

The town hall in Grimma, the pearl of the Mulde Valley, is one of the most beautiful municipal buildings of the Saxon Renaissance. Grimma began life as a market town on a river crossing in 1170 but gradually paled into insignificance beside its larger neighbour in trade Leipzig.

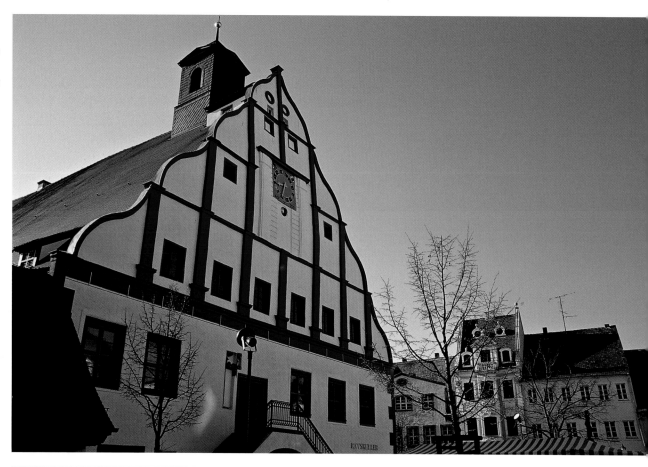

Atop a porphyry plate on the banks of the River Elbe in the Torgau is Schloss Hartenfels which Ernestine electors had turned into a magnificent four-wing residential palace from 1470 onwards. Famous architects were asked to help with its refurbishment, among them Konrad Krebs, whose work includes the masterly Großer Wendelstein spiral staircase.

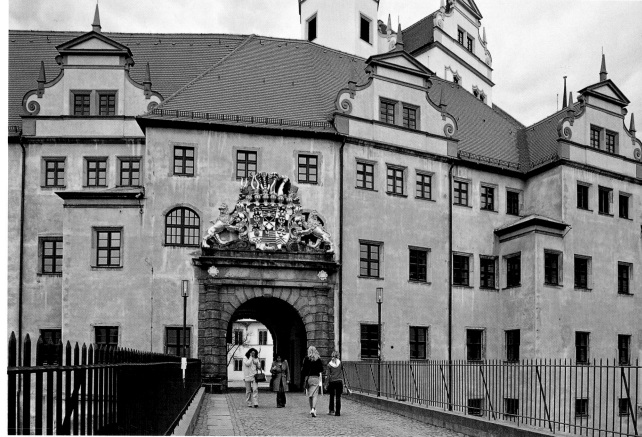

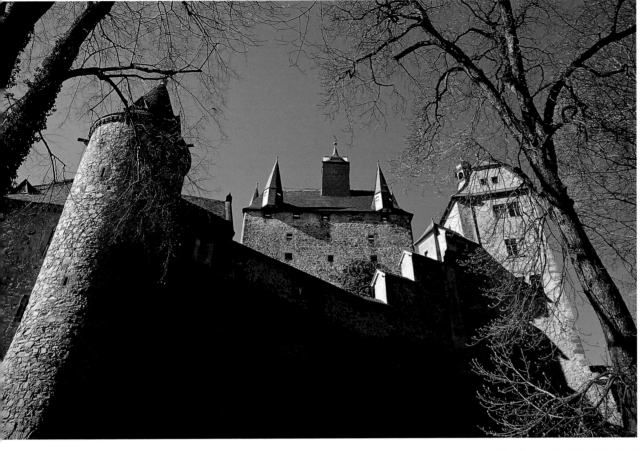

North of Mittweida Burg Kriebstein clings to a promontory surrounded on three sides by the River Zschopau. At the highest point of the cliff stands the mighty keep with its late medieval turrets.

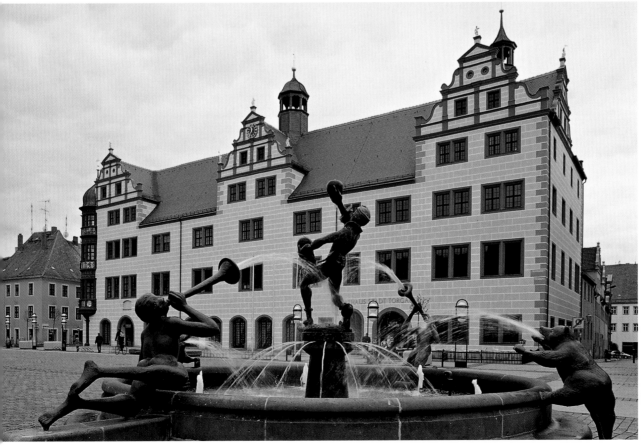

At the beginning of the 16th century the electors of Saxony made Torgau their residential headquarters. The town grew to become the political centre of the Reformation, experiencing a boom which is still manifested in its splendid Renaissance buildings, among them the town hall (shown here).

C H E M N I T Z ' S

In the little town of Seiffen in the Erzgebirge, where wooden toys and Christmas decorations are made, a ring turner works on a template. This will be split into discs to produce model animals which are then finished and painted.

You won't hear church bells ringing in the "cathedrals" of Chemnitz; evil black smoke once poured out of them, earning Saxony's industrial metropolis the epithet "the city of soot". The men behind these imposing monuments to industrial architecture were the factory owners of the "Gründerzeit" who, like the religious and worldly leaders before them, wanted to manifest their power and wealth in edifices which were aesthetically pleasing.

The 800-year-old city of Chemnitz has always been an industrious place. It all began with the manufacture and sale of cloth and thread. In 1799 a revolution took place; the first machine-operated spinning mill went into operation, heralded as Saxony's first factory. The town became the hub of textiles and tool machine manufacture and the automobile industry, with looms and locomotives from Chemnitz being exported all over the world, planes and cars following in their wake. Inspired by the work of scholar, mayor and "founder" of the coal and steel industry Georgius Agricola, a man who effected an exemplary synthesis of engineering, science and art, in 1836 a royal school of trade opened its doors, now a flourishing technical university. Together with Zwickau, Chemnitz is West Saxony's economic and cultural driving force, a "city with brains" and an "InnovationsWerkStadt" (innovative work place), to quote its advertising slogans. Chemnitz is also famous for sport; as early as in 1910 there were over 100 sports clubs serving around 30,000 members. The city was called Karl-Marx-Stadt between 1953 and 1990; the huge bronze bust of the great thinker, who incidentally never came here, is a reminder of this phase in its history. It was during this period that the skills of East German athletes from the Sportclub Karl-Marx-Stadt were feared at tournaments the world over, with no less than 400 medals to prove it.

The chimneys have long ceased belching smoke; Chemnitz is no longer grey and dismal but green and cheerful. The nearby countryside is a place of great natural beauty, the mountains of the Erzgebirge and the romantic river valleys of the Mulde and Zschopau with their castles and palaces a mere stone's throw away. The absolute gem of the region is the grand Renaissance palace of Augustusburg, the elector of Saxony's "hunting lodge": an excellent example of the often perfect marriage of authority and art.

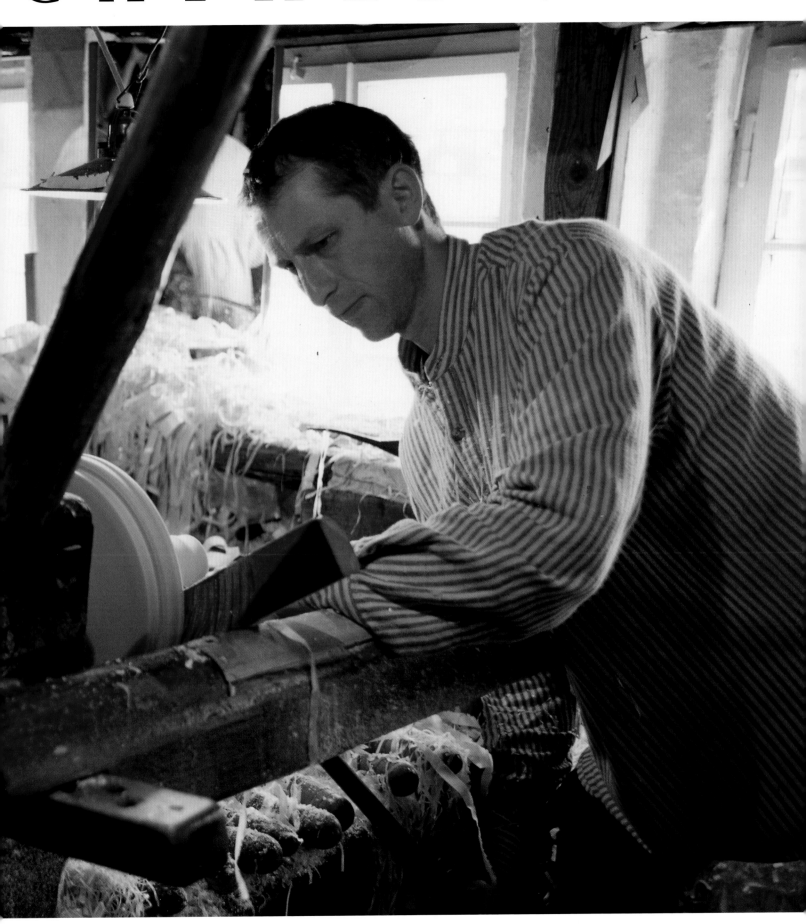

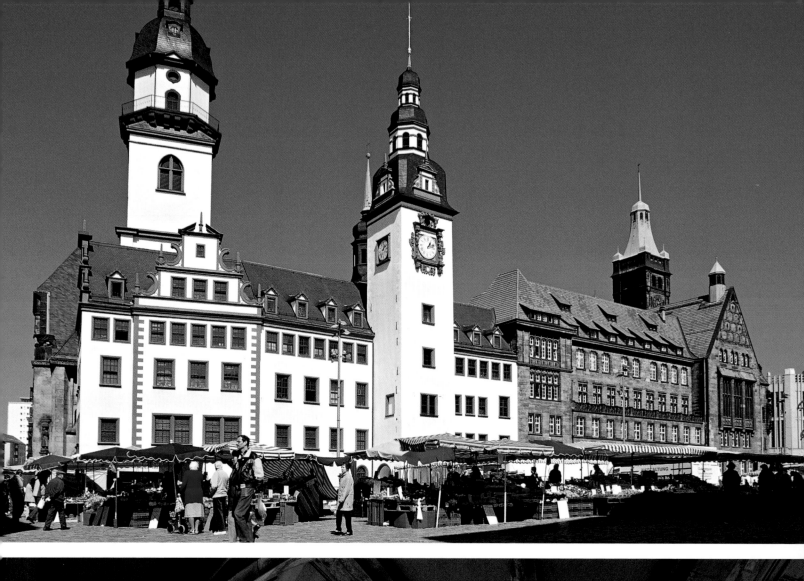

the market square in
emnitz the late Gothic
tes Rathaus borders
its newer neo-Renais-
nce and Jugendstil
ntemporary. Both are
rth a visit, the former
its reconstructed

Ratsstube and stellar
vaulting, the latter for
its unusual Jugendstil
furnishings and a
portrait of Max·Klinger
from Leipzig bearing the
curious title of "Work,
Prosperity, Beauty".

Below left:
In the 18th century cotton
weaving and calico
printing were the main-
stays of the Chemnitz
economy. Splendid
patrician houses, such

as this one on Innere
Klostergasse, are remind-
ers of the great wealth
the city once enjoyed as
a major centre of the
textiles industry estab-
lished in the Middle Ages.

he Siegertsches Haus
uilt for a wealthy
erchant is painted in
e vibrant pink and
hite of the baroque.
ot far from here was

the home of Georg Bauer
or Georgius Agricola, the
founder of the coal and
steel industry and doctor
and mayor to the city of
Chemnitz.

Above:
The Altes Rathaus in
Chemnitz has been care-
fully reconstructed
following its destruction
during the Second World
War. The town hall

tower now bears a portal
from one of the city's old
Renaissance houses
which was also bombed
during the war.

Nossen on the Freiberger Mulde boasts an impressive castle. The knights of Nuzzin inhabited the first fortification on this site until 1315. During the 16th century the castle was extended and rebuilt as an electoral palace using masonry from the nearby Kloster Altzella which was dissolved in the wake of the Reformation.

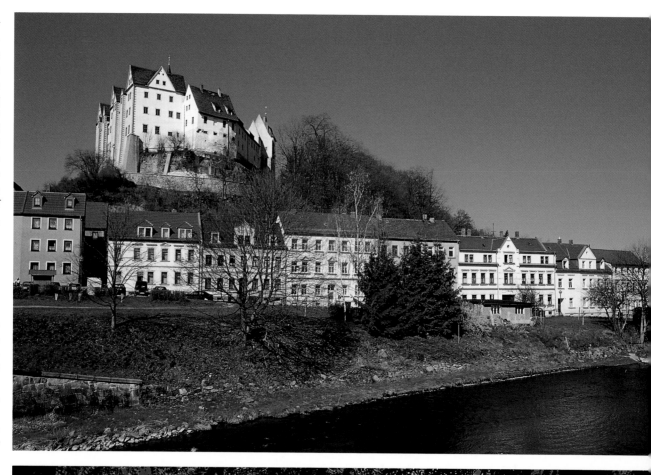

Right page:
Renaissance Schloss Thallwitz on the Mulde between Eilenburg and Wurzen was erected in c.1570. 300 years later Arwed Roßbach transformed it into a hunting lodge for the princes of Reuß. During the 1990s the building was completely gutted and restored after having been used as a hospital for 50-odd years.

Count Heinrich von Brühl, then the future prime minister of the electorate of Saxony, acquired Schloss Nischwitz in 1743 and had it turned into a lavish summer residence decked out in late baroque Rococo. The count was a liberal spender – which came as no surprise when after his death it was discovered that he had relieved the state coffers of no less than 4.6 millions thalers ...

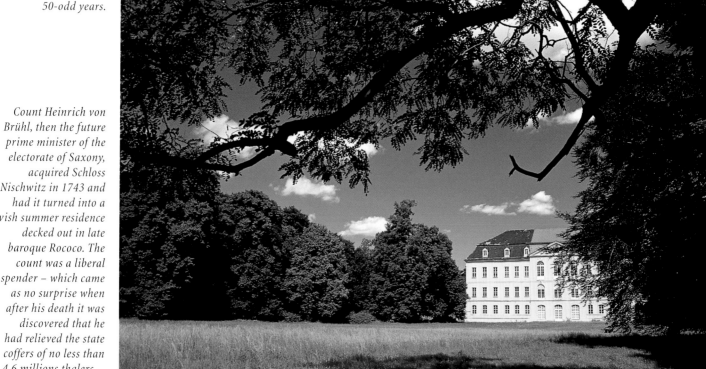

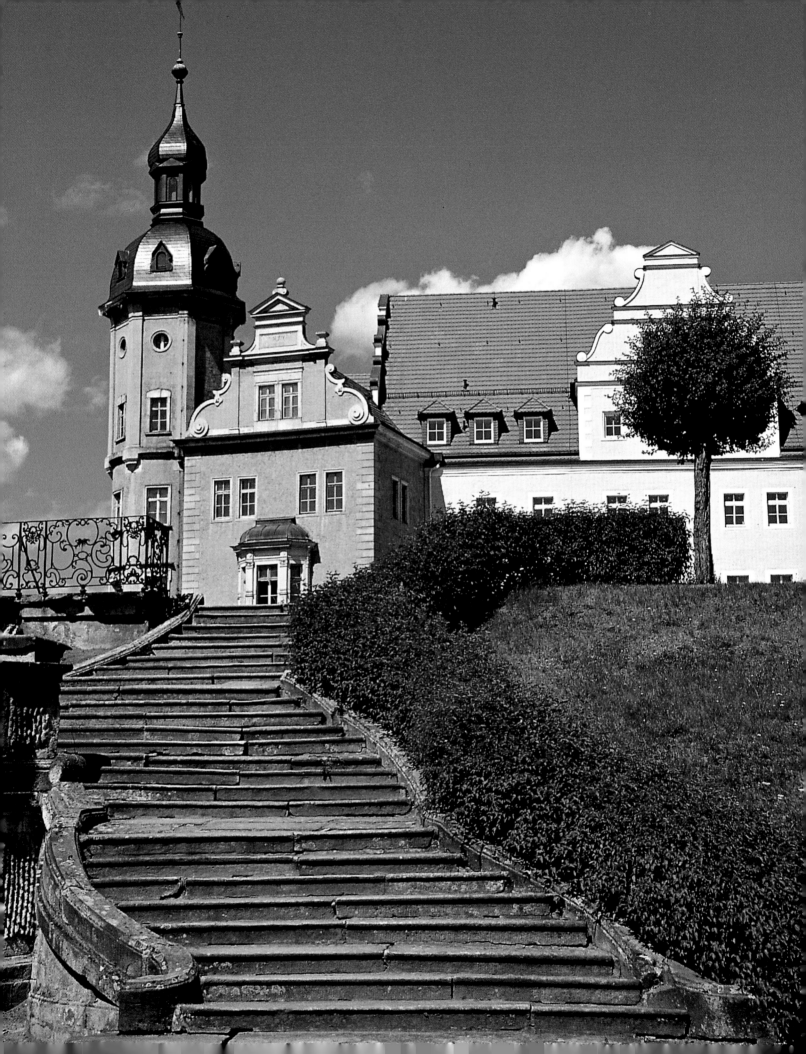

Silver was first discovered in Saxony in 1168. Miners flocked to the area and Freiberg became the first free mining town in Germany. The fountain on Obermarkt with its statue of Margrave Otto the Rich marks the spot where in 1455 Kunz von Kaufungen was beheaded for kidnapping two young princes from Schloss Altenburg at the height of a feud with the elector. Princes Ernst and Albert were found unharmed; the kidnapping has since become something of a local legend.

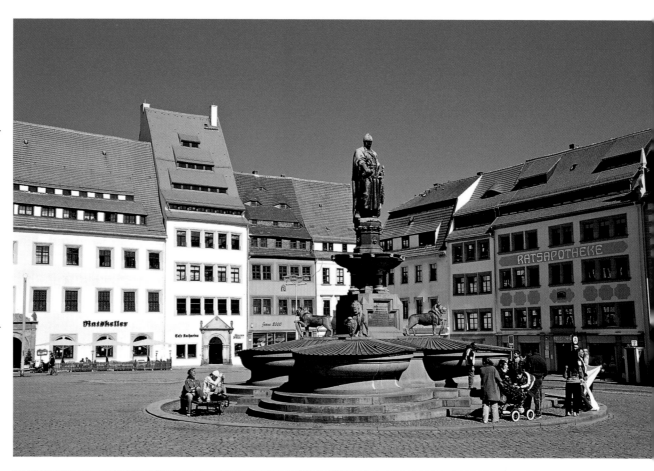

Freiberg's cathedral was built at the height of the city's economic and cultural prosperity during the 16th century. It contains many precious treasures, among them the lavish tulip-shaped pulpit, the miner's pulpit, the largest Silbermann organ to have survived and the Goldene Pforte or Golden Gate, a unique, once brightly coloured portal of ornate figures.

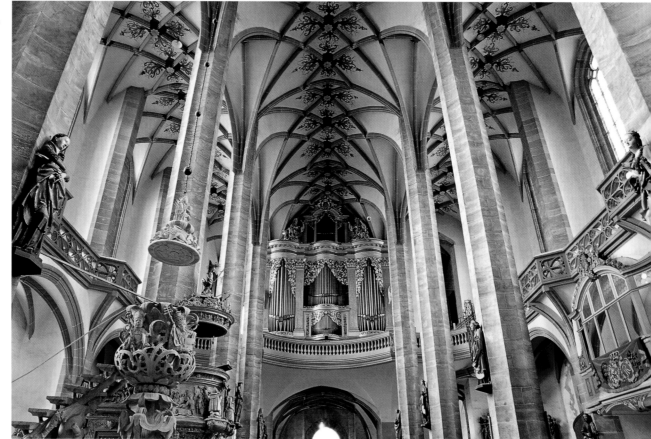

The old town in
Freiberg has over four
hundred historic build-
ings which are more
than three centuries old.
The city museum at the
Domherrenhof is also
a museum of the history
of mining.

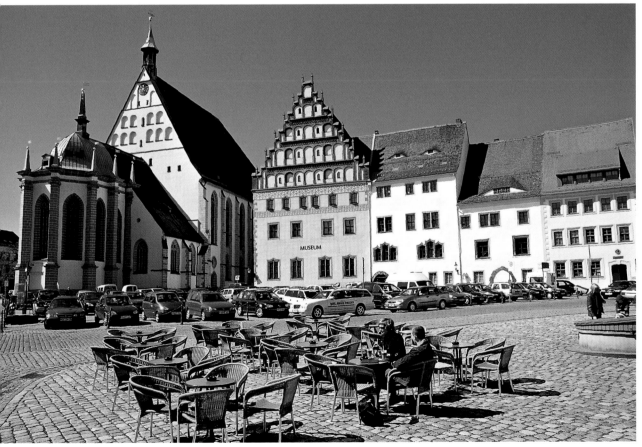

The simple facade of
Freiberg Cathedral gives
no clues as to the sump-
tuous interior which
awaits the unsuspecting
visitor. When in 2002 the
high choir was restored
most of the violins, lutes,
harps and shawms the
cherubs had been "play-
ing" since the 16th cen-
tury, 12 metres (40 feet)
up above the floor where
the electors lie buried,
were found to be genuine.

Above:
In the Osterzgebirge near Frauenstein, home of the great organ builder Gottfried Silbermann (1683–1753) to whom the town has dedicated a museum. 31 of the 46 magnificent organs produced at his workshop still exist today.

Right:
The Saxon Vogtland bordering on Thuringia, Bavaria and Bohemia has a broad and colourful scenic spectrum which includes deep river valleys, steep hillside slopes, mountain peaks and open country.

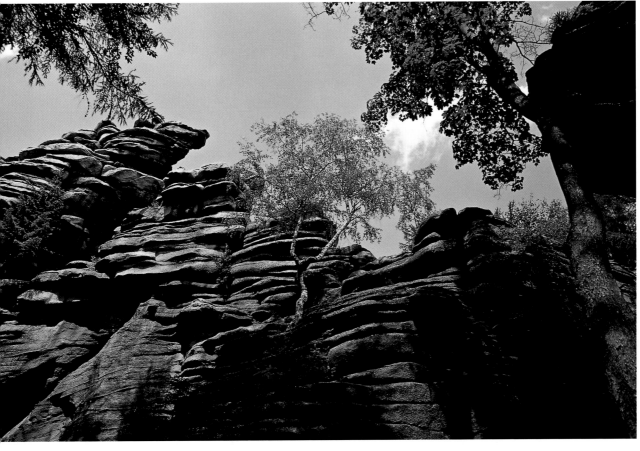

The Greifensteine region in the Erzgebirge is a popular with holiday-makers who come here to explore the underground world of mining, to hike through the forest and to swim in its many pools and lakes. There's also grass skiing in the summer, cross-country skiing in the winter and open-air concerts and plays at the Naturbühne Greifensteine.

The Erzgebirge (or Krusné hory in Czech) stretches 130 kilometres (81 miles) across the south of Saxony. The national border with the Czech Republic runs along its ridge, with its historic boundary lying between Saxony and Bohemia. The highest mountain on the Czech side is the Klínovec at 1,244 metres (4,081 feet), with the second highest, the Fichtelberg (1,214 metres/3,983 feet), in Germany. The "ore mountains" are named after the rich natural deposits mined here from the 12th century onwards.

Below:
The open air museum at Seiffen explores everyday life in the central Erzgebirge during the 19th and at the beginning

of the 20th century, dominated by the toymaking profession and other trades involving the processing of wood. A water- powered lathe,

a sawmill and tiny cottages-cum-workshops clad in wooden shingles illustrate how the people of the age lived and worked.

Top right:
In the characteristic houses of the region the main living room with its Dutch stove, the larder,

animal pens or workshops are on the ground floor with the bedroom and stores above

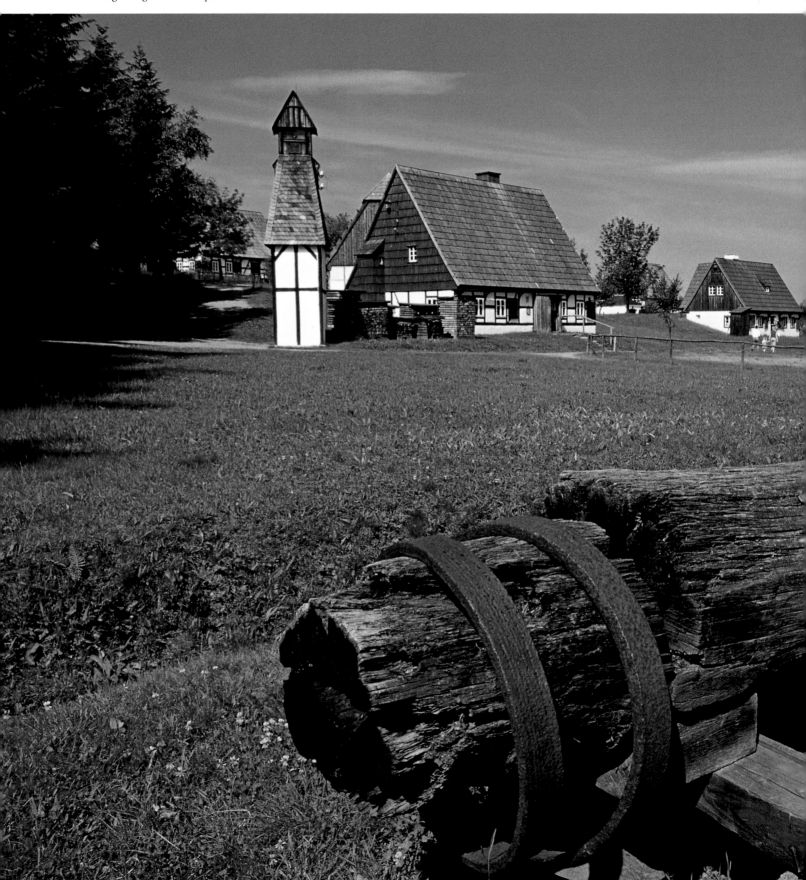

Centre right:
Wooden decorations from the Erzgebirge and colourful window boxes brighten up the simple half-timbered or stone facades of local houses.

Bottom right:
The open-air museum is a collection of buildings complete with historic furnishings which have been removed from their original location and reconstructed on site. There's even a village shop.

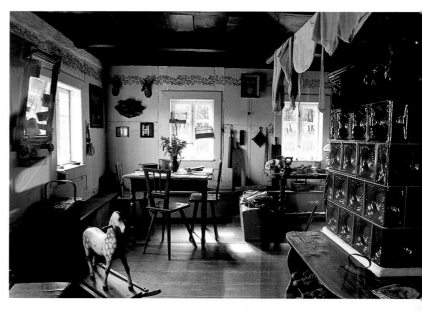

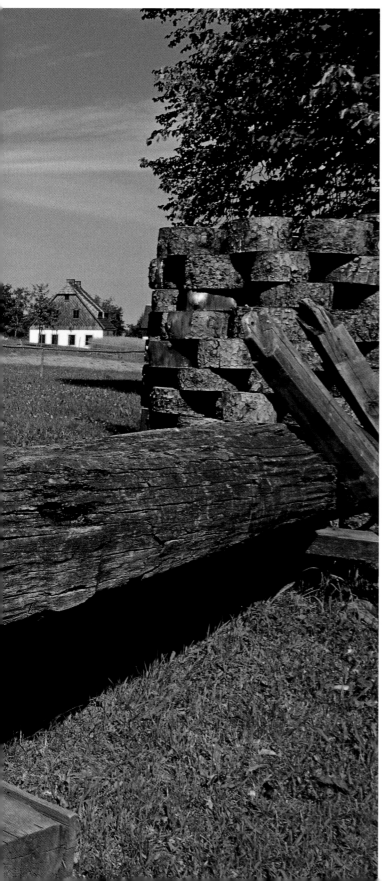

Wooden figures wearing traditional Erzgebirge dress. The miner is usually depicted with an angel of light. In the run up to Christmas people used to place these figures in their windows, with an angel for each little girl in the house and a miner for each little boy.

...a t least that's what the miners of the Erzgebirge once claimed. Silver was first discovered here in the 12th century. The rich pickings underground soon attracted permanent settlers; the precious metal they extracted made Saxony rich. In the midst of dense forest powerful cities shot out of the ground, adorned with spacious market squares, elegant patrician houses and magnificent chapels and churches, among them Freiberg, Schneeberg, Annaberg and Marienberg. Sankt Joachimsthal, now Jachymov in the Czech Republic, was another where in the 16th century Joachimsthal groschen were minted as the silver equivalent of the golden guilders of the Rhine.

Not only silver and iron ore were mined. Tin was extracted and turned into elaborate tableware, lead was made into printing stamps for books and cobalt was used to dye glass and paint porcelain. The abundance of ore gave the Erzgebirge or "ore mountains" their name. Yet with the limited mining equipment of the day these natural resources soon proved impossible to access. Many miners were forced to seek alternative sources of income, turning to time-honoured crafts such as carpentry, woodwork and carving to survive. The furniture, household objects and ornamental figures they fashioned didn't make them rich; they did, however, establish a tradition which has since been inextricably linked with the Erzgebirge: the manufacture of wooden toys and Christmas decorations.

The selection of products is huge, ranging from the first rather naive crib figures and ring-turned animals to expertly modelled collector's items and splendid Christmas pyramids; from celestial angels of light to fierce-looking, teeth-gnashing nutcrackers; from kindly pipe smokers to angelic flower children. Boxes of bricks and model farmyards, doll's houses and general stores, spinning tops, marbles, bowls and balls and miniature trains all came from the Erzgebirge to steal the hearts of children far and wide. Some of the traditional workshops are now open to the public; in the run up to Christmas market places are lit up by enormous pyramids gently spinning in the heat generated by their candles. The toy village in Seiffen is open to kids big and small all year round, the ancient buildings and workshops providing visitors with a riveting insight into the history of craft in the Erzgebirge.

Magnificent witnesses to the communal blossoming of the mining industry and of art and architecture in the Middle Ages are dotted all along the Silberstraße which traces the ancient silver transportation route from Zwickau through the Erzgebirge to Dresden. There's plenty to discover and enjoy along the way: a bevy of marvellous architectural monuments in the old silver towns and numerous mines and museums set in beautiful surroundings. This harmonious union of the creations of man and nature is Saxony – or at least was. Such was the need for new-found forms of energy that during the 19th century things suddenly went horrendously off track. The robust deciduous forest of the Erzgebirge was largely replaced by colonies of conifers, which grew faster and were commercially more viable yet more susceptible

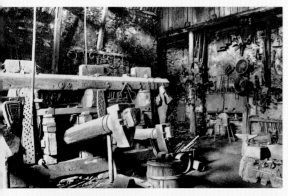

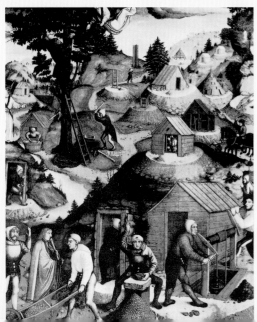

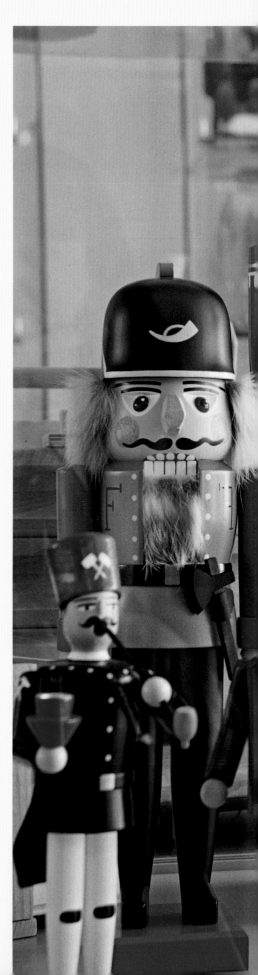

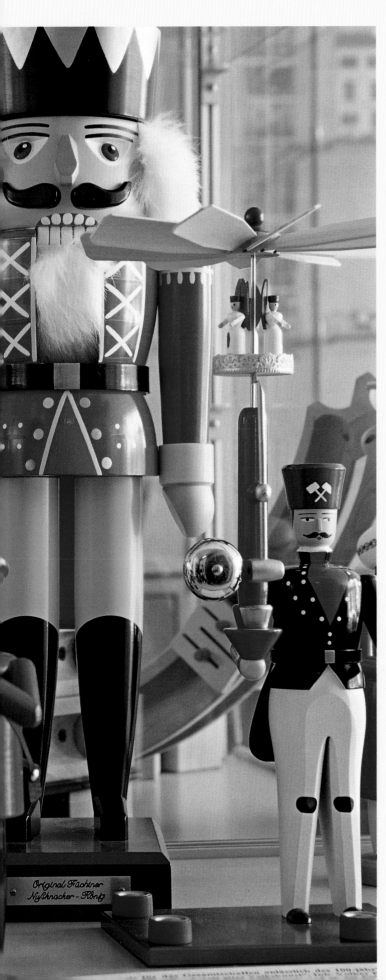

Right:

A giant seam of hard coal was discovered on the edge of Oelsnitz in 1844. In 1923 a new red-brick winding tower was erected which is still visible for miles around. The last tram trundled out of the deep mine shaft in 1971. The complex reopened as a mining museum in 1986.

Left:

Nutcrackers have been made in the Erzgebirge since the mid-19th century. The nutcracker in one of Heinrich Hoffmann's picture books is said to have been the model for the first originals.

Top far left:

Tools were fabricated and coins minted at Frohnau near Annaberg for centuries until the plant closed in 1904. The three tilt hammers were powered by water, pounding the metal with tons of force. Demonstrations of the smallest of the three are given at the museum.

Bottom far left:

These scenes depicting the life of local miners by Hans Hesse adorn the back of the miners' altar from 1521 in the St Annenkirche in Annaberg.

to disease and pollution. Huge swathes of forest fell victim to the toxic emissions of North Bohemia's industrial environment. Today the area is being replanted with deciduous trees.

Not only the trees died. The exact number of miners and locals killed by the extraction of uranium ore for the Soviet Union between 1946 and 1989 will never be known. In the early years working conditions were lethal; safety measures, most of them totally ineffective, were only introduced later. The Erzgebirge was the only source of uranium the Soviets had access to and was absolutely essential in the arms race against the USA. Yet an entire army of Stasi officials made sure that not much other than lethal radon gas leaked out from the tunnels of the Wismut-AG. "Wismut miners keep world peace" was the slogan used to market the deadly operation: outrageous dialectics or an exercise in cynicism?

In 1996 the western and central areas of the Erzgebirge were incorporated into the Naturpark Erzgebirge/Vogtland. The national park is serviced by well-maintained hiking trails, cycling tracks and bridleways, cross-country ski and toboggan runs. The eastern region of the mountains is no less attractive with its colourful alpine meadows, cosy holiday homes in secluded villages and warm hospitality. The Bohemians on the other side of the mountains are no less welcoming; a foray out into the Czech Republic is heartily recommended.

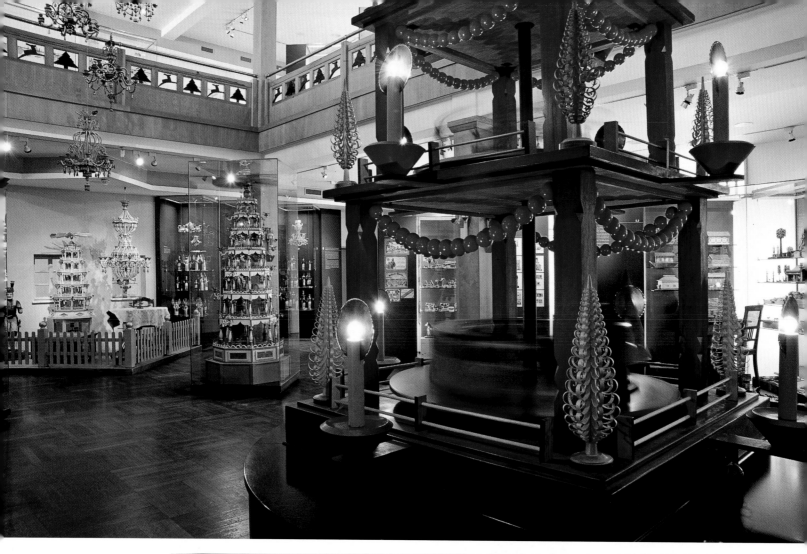

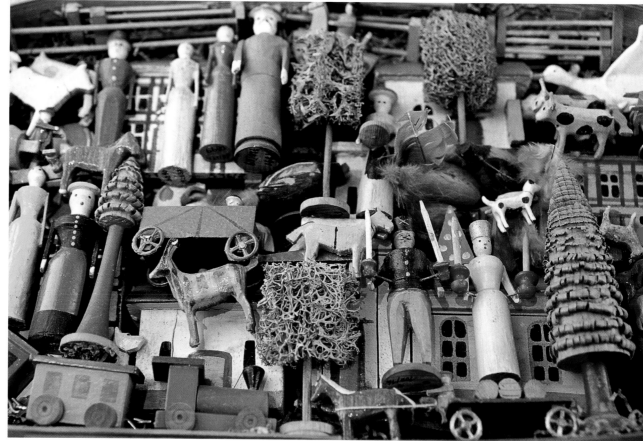

Above:
The first Christmas pyramids were fashioned in the Erzgebirge back in the 18th century. Platforms of carved figures are attached to the central axis of the pyramid. Flat wooden blades are set into the top at an angle which turn the pyramid when the warm air from the candles rises.

Right:
History comes alive at the toy museum in Seiffen. With the closure of the pits many miners were forced to turn their hand to woodcarving to make a living – with impressive results.

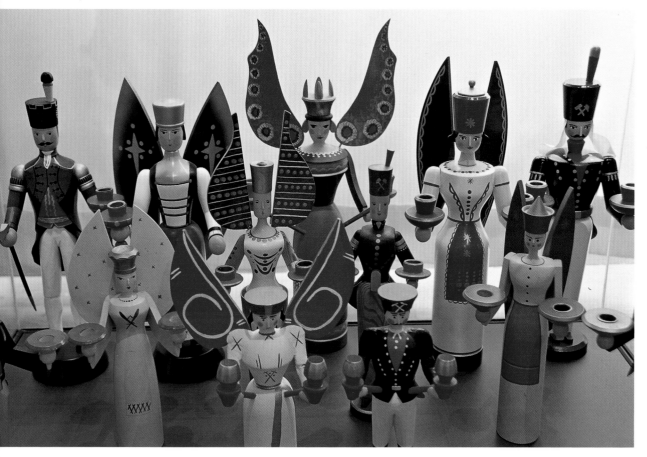

Left:
These candleholders brighten up the wait for Christmas. The toy museum in Seiffen has the full range of wooden Erzgebirge toys and ornaments on display, from soldiers to castles to building bricks, from doll's houses to general stores to farmyards.

Below:
Toymakers were usually self-employed, with many working from their family home. Their income was low and their living conditions extremely modest; twelve- or thirteen-hour days and child labour were also not uncommon.

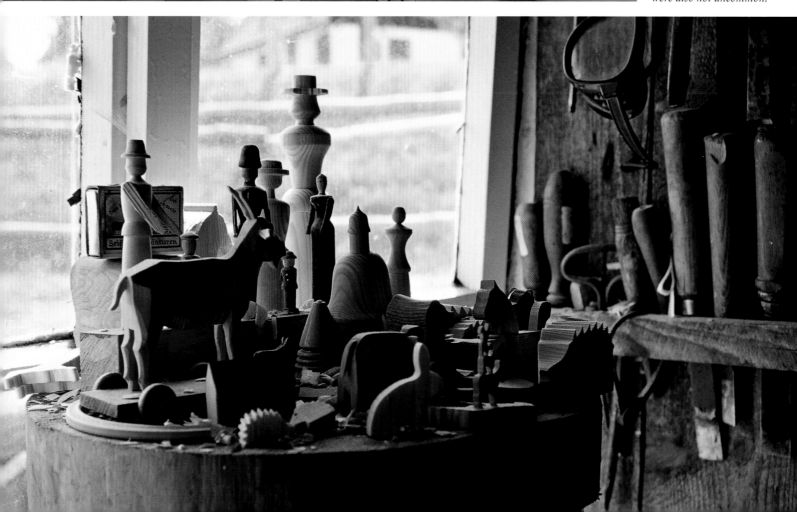

At the end of the 15th century Duke George founded Annaberg after rich silver deposits were unearthed in nearby Schreckenberg Mountain. Joined with Buchholz to form Annaberg-Buchholz in 1945, the town is one of the most scenic stops along the Sächsische Silberstraße (Saxon Silver Route).

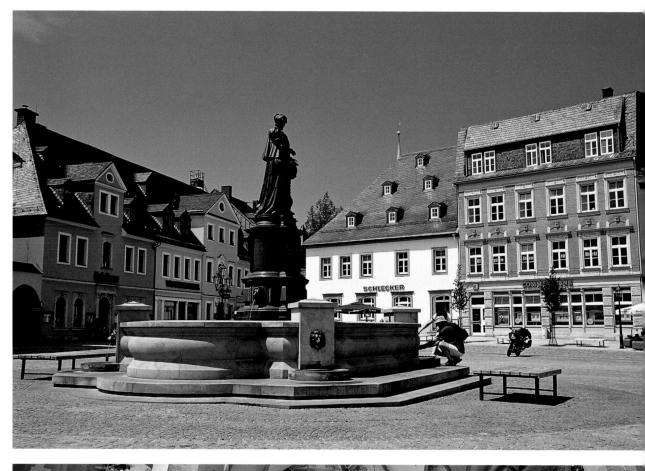

Right page:
Besides the three altars donated by the miners', the minters' and the bakers' guilds, two carved altars by Christoph Walter I can also be found in Saxony's largest hall church in Annaberg.

The St Annenkirche, built between 1499 and 1525, is heralded as the architectural climax of the Upper Saxon late Gothic period. The gallery balustrades of the white and ochre interior with its magnificent rib and stellar vaulting are decorated with a hundred reliefs by Franz Maidburg depicting scenes from the Old and New Testament.

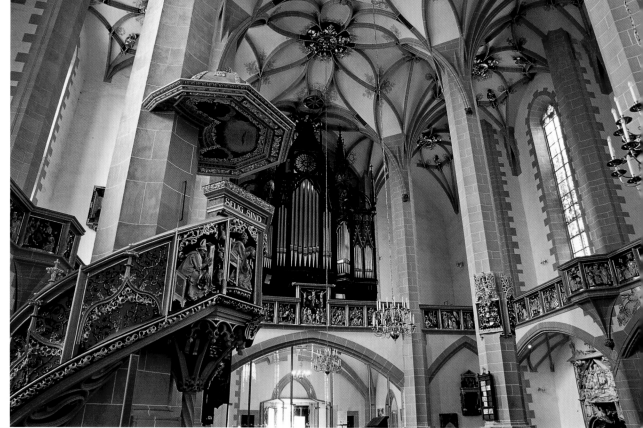

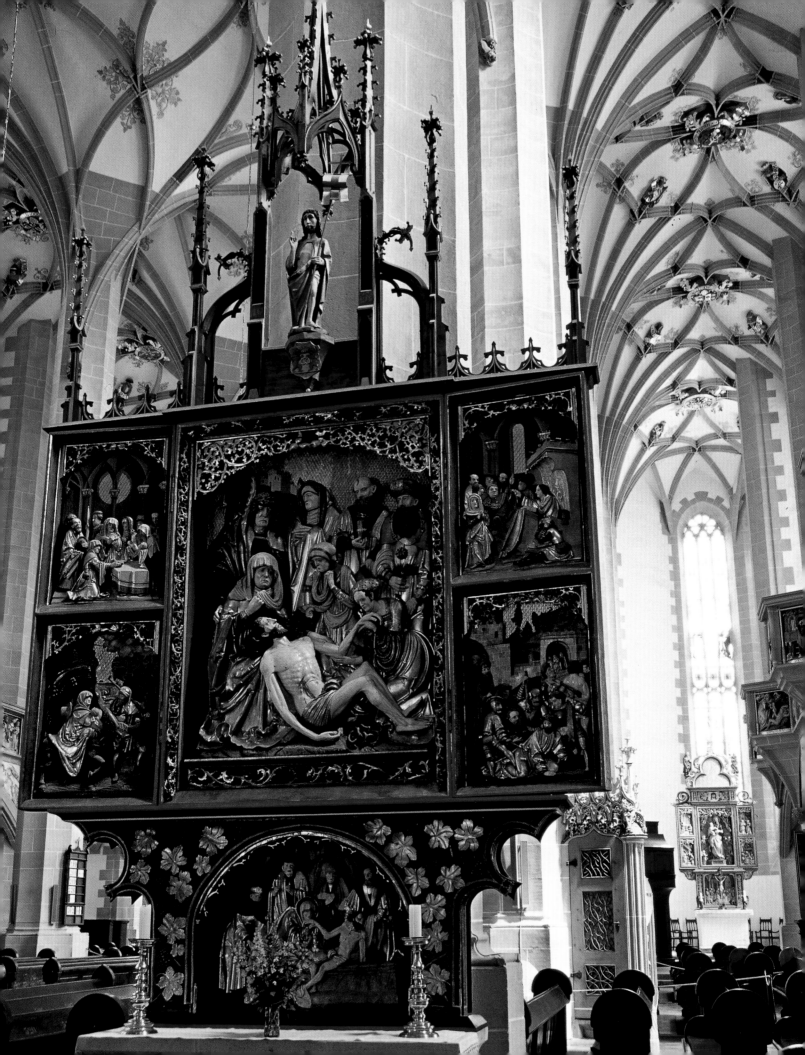

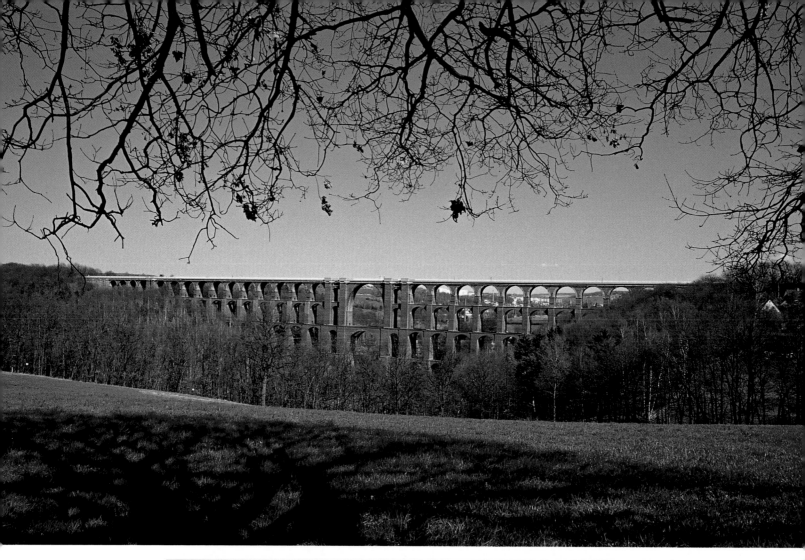

Above:
The bridge over the Göltzsch Valley in the Vogtland was erected between 1846 and 1851 by the Saxon-Bavarian railways for trains running from Leipzig to Nuremberg. Over 26 million bricks were used, with granite making up the foundations, pillars and arches. Over thirty people lost their lives working on the extremely perilous project. At the time of its completion it was the highest railway bridge in the world.

Right:
Plauen is the cultural and economic centre of the Vogtland. The Renaissance gable of the late Gothic Altes Rathaus bears Plauen's local landmark, a marvellous array of timepieces.

Left:
Schloss Netzschkau in the north of the Vogtland with its bright white walls and deep red ornamental masonry was built by Caspar David Metzsch in c.1490. It's considered to be one of the most beautiful early residential castles in Saxony.

Below:
Following several fires the cathedral of St Mary's in Zwickau was rebuilt in late Gothic in 1453. Walking round the exterior you will discover ca. 70 limestone figures depicting various famous people; the Apostles adorn the south facade, the prophets the east and the secular players of the Reformation the north.

Above:
At what was once an embroiderer's workshop visitors to Plauen-Reusa can watch demonstrations of how lace and embroidery were made. The first two manual embroidery machines began operation in Plauen in 1856, with over 900 installed at 231 factories by 1872. Lace from Plauen won the Grand Prix at the World Exposition in Paris in 1900.

Right:
From lace doilies for the dresser to bridal gowns, from lace curtains to ornamental collars: lace and embroidery from Plauen allowed the lower classes to emanate the styles and fashions of the aristocracy.

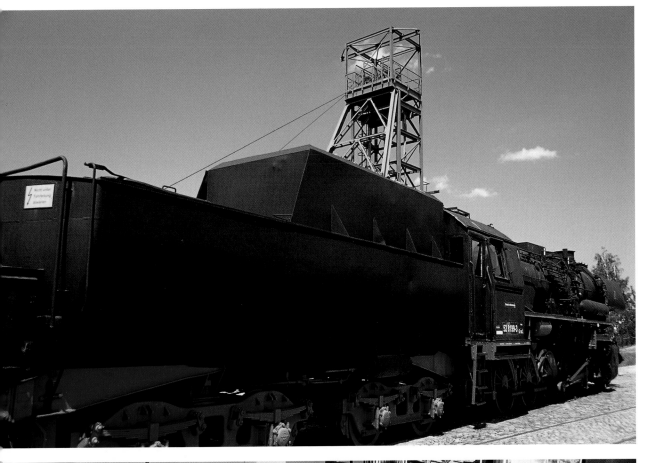

The traditional miner's greeting of "Good luck!" still resounds at the old colliery in Lugau-Oelsnitz – albeit from the lips of visitors and guides alone. A restored locomotive and two huge winding towers invite you to step inside and explore Saxony's biggest industrial museum.

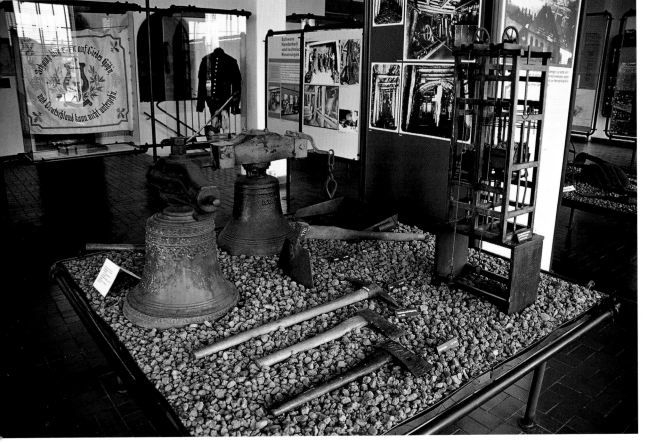

In 1971 the pit at Lugau-Oelsnitz was closed, leaving 2,000 local miners out of work. 15 years later the pit reopened as a museum of mining, providing a valuable insight into a way of life which was marked by toil and hardship.

I N D E X

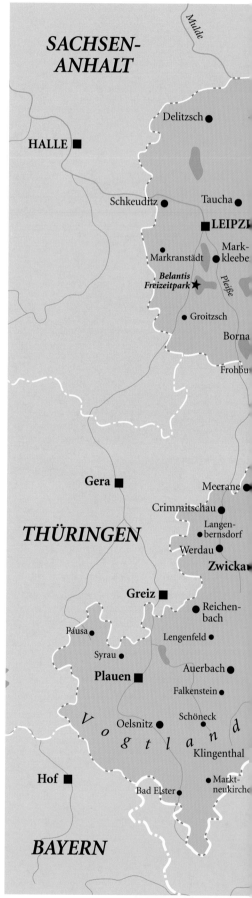

SACHSEN-ANHALT

Mulde

Delitzsch

HALLE

Schkeuditz — Taucha

LEIPZIG

Markranstädt — Markkleebe

Belantis Freizeitpark — Pleiße

Groitzsch

Borna

Frohbu

Gera

Meerane

Crimmitschau

Langenbernsdorf

THÜRINGEN

Werdau

Zwicka

Greiz

Reichenbach

Pausa

Lengenfeld

Syrau

Plauen

Auerbach

Falkenstein

Vogtland

Oelsnitz

Schöneck

Klingenthal

Hof

Bad Elster

Marktneukirche

BAYERN

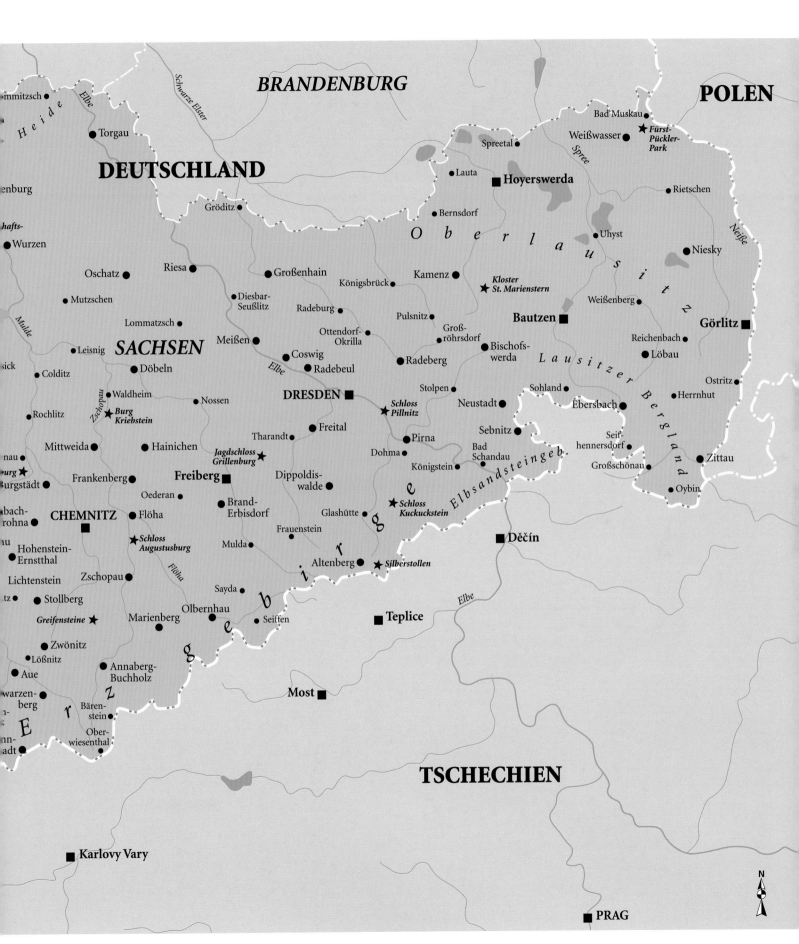

BRANDENBURG

POLEN

DEUTSCHLAND

Heide

mmitzsch

Elbe

Torgau

Schwarze Elster

Bad Muskau

Spreetal

Weißwasser

★ *Fürst-Pückler-Park*

Lauta

Rietschen

enburg

Gröditz

Hoyerswerda

Bernsdorf

O b e r l a u s i t z

Uhyst

Niesky

hafts-
Wurzen

Oschatz

Riesa

Großenhain

Königsbrück

Kamenz

★ *Kloster St. Marienstern*

Weißenberg

Mutzschen

Diesbar-Seußlitz

Radeburg

Pulsnitz

Groß-röhrsdorf

Bautzen

Görlitz

Mulde

Lommatzsch

SACHSEN

Meißen

Coswig

Ottendorf-Okrilla

Reichenbach

Löbau

Leisnig

Döbeln

Elbe

Radebeul

Radeberg

Bischofs-werda

L a u s i t z e r B e r g l a n d

Ostritz

sick

Colditz

Rochlitz

Waldheim

Zschopau

★ *Burg Kriebstein*

Nossen

DRESDEN

Stolpen

Neustadt

Sohland

Ebersbach

Herrnhut

★ *Schloss Pillnitz*

Mittweida

Hainichen

Tharandt

Freital

Pirna

Sebnitz

Seif-hennersdorf

nau

Jagdschloss Grillenburg ★

Dohma

Bad Schandau

Großschönau

Zittau

urg ★

Frankenberg

Freiberg

Dippoldis-walde

Königstein

Elbsandsteingeb.

Oybin

burgstädt

Oederan

Brand-Erbisdorf

Glashütte

★ *Schloss Kuckuckstein*

Děčín

bach-rohna

CHEMNITZ

Flöha

Frauenstein

e

g

Hohenstein-Ernstthal

★ *Schloss Augustusburg*

Mulda

Altenberg

★ *Silberstollen*

i

Teplice

Lichtenstein

Zschopau

Flöha

Sayda

r

tz

Stollberg

Olbernhau

Seiffen

Elbe

b

Greifensteine ★

Marienberg

g

Zwönitz

e

Most

Lößnitz

Aue

Annaberg-Buchholz

z

hwarzen-berg

Bärenstein

r

E

Oberwiesenthal

TSCHECHIEN

nn-adt

Karlovy Vary

N

PRAG

123

On February 25, 1912, Karl May celebrated his 70th birthday. On March 22 he was invited to Vienna by the Academic Board of Literature and Music to give a speech in front of 2,000 people in which he spoke of peace. He found it on March 30 when he died at his home, Villa Shatterhand. He lies buried in a mock temple at the cemetery in Radebeul-Ost.

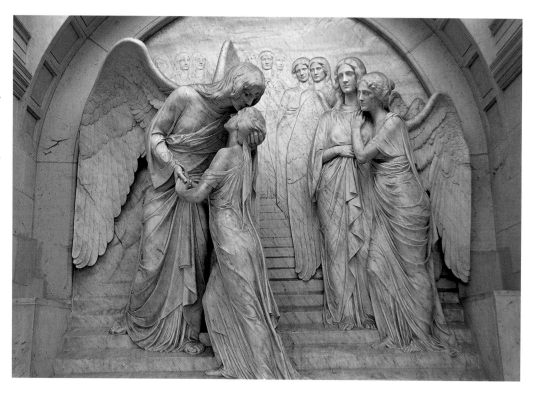

Credits

Design
hoyerdesign grafik gmbh, Freiburg

Map
Fischer Kartografie, Aichach

Translation
Ruth Chitty, Schweppenhausen

All rights reserved

Printed in Germany
Repro by Artilitho, Lavis-Trento, Italy
Printed/Bound by Offizin Andersen Nexö, Leipzig
© 2007 Verlagshaus Würzburg GmbH & Co. KG
© Photos: Tina und Horst Herzig

ISBN 978-3-8003-1644-1

Details of our programme can be found at
www.verlagshaus.com

Photographers
Tina and **Horst Herzig** live in Bensheim and work as freelance photographers and designers. They have had illustrated books on France, Denmark and England published by Verlagshaus Würzburg.

Author
In this book **Sylvia Gehlert**, an expert on Romance and Germanic languages and literature, discovers her native Saxony anew. She currently teaches at a French university and works as an author and translator for publishing houses in France and Germany.

Stürtz

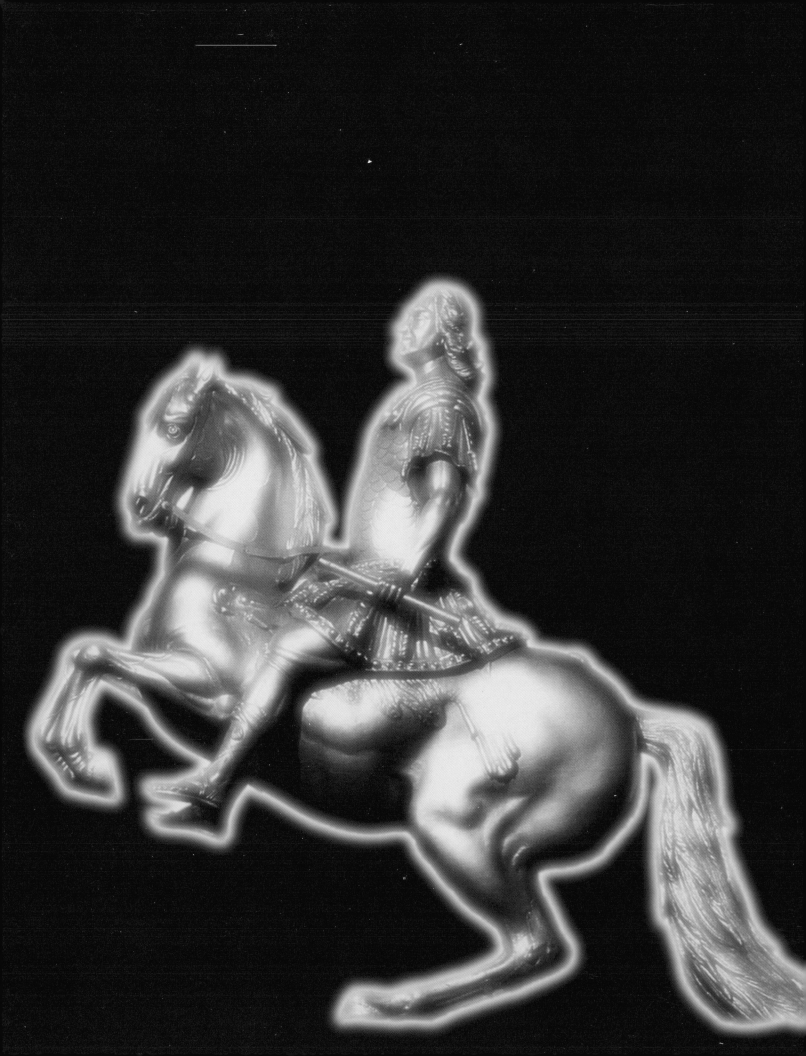